UNSUCCESSFUL THUG

UNSUCCESSFUL
THUG

One Comedian's Journey from
Naptown to Tinseltown

MIKE EPPS

HARPER
An Imprint of HarperCollins*Publishers*

UNSUCCESSFUL THUG. Copyright © 2018 by Mike Epps. All rights reserved. Printed in the United States of America. No part of this book may be used or reproduced in any manner whatsoever without written permission except in the case of brief quotations embodied in critical articles and reviews. For information, address HarperCollins Publishers, 195 Broadway, New York, NY 10007.

Insert photographs are courtesy of the author.

HarperCollins books may be purchased for educational, business, or sales promotional use. For information, please email the Special Markets Department at SPsales@harpercollins.com.

FIRST EDITION

Library of Congress Cataloging-in-Publication Data has been applied for.

ISBN 978-0-06-268489-9

18 19 20 21 22 LSC 10 9 8 7 6 5 4 3 2 1

FOR ALL MY CHILDREN

CONTENTS

Prologue 1

1 Archangel Michael 5

2 The Baddest Kid in School 27

3 The House at Carrollton and Dirty-Third 43

4 Our Forty Acres and a Mule 61

5 To Grandmother's House We Go 71

6 The TV Show on Central 91

7 Crime Doesn't Pay—Unless It's Paying You 101

8 Jail, Prison, and Work Release 121

9 A Comedy Club and a Sewer in Atlanta 143

10 Biting into the Big Apple—with a Broken Tooth 153

11 Acting Lessons on Madison Avenue 171

12 An Audition and a Funeral 183

13 Forever Day-Day Jones 195

14 "Remember the Time" 209

15 A Moment for the Women in My Life 217

16 Hollywood Is Stephen Decatur High School 229

17 Being Richard Pryor 243

 Epilogue: Hollywood to Naptown 257

UNSUCCESSFUL THUG

If I'd had an ounce of sense—no, *an eighth* of sense—I never would have made it in show business.

I like to consider myself one of the most afraid, mischievous, strong, God-fearing, tempted, confused, criminal-minded, funny, lovable, shy entertainers in the world, but none of those things got me where I am today. I didn't care about getting famous—I just wanted to live. And I didn't even care about being a famous comedian. I just had to survive. I didn't want to be a star. It would be a disservice to myself to say that, because that's not how I became who I became. I became who I became by surviving.

When I talk to other successful people in show business, I sometimes feel embarrassed, because I'm not in it for the same reasons they are. This isn't a *career* to me. This is my *life*. Show business is what I do to survive. It's my therapy, because I constantly need someone to talk to. It's my parole, because if I violate it, I go back to my life before. And it's my spirituality, because I definitely feel like God is using me for therapeutic purposes.

Don't get me wrong—I'm proud of where I came from.

I used to get intimidated by the fact that I was from a small town until I realized that there are real people from all over the world who come from places you never heard of. You just never met them. And there are a lot of people who wonder how a guy like me who comes from the middle of America can make it in Hollywood and tour the world. Well, I can run through this shit for exactly one reason: because of how I came up.

But it wasn't easy. I know you've heard a lot of hard-shit stories. I'm only responsible for mine. I had to become a chameleon. I learned to change up my looks and my attitude so I could move from one environment to another without being found out. It's the best training there is for being an actor. Or a serial killer. Luckily, I was just a good dude who made some bad mistakes.

Sometimes I feel like I'll never be able to relate well to all these people here in Hollywood who grew up with enough to eat, houses with doors that locked, and no jail cells slamming on you when you're sixteen. Sometimes I wish there was a way for each of us to see what the other sees. Not like I wish my life on anybody, but I think if we could all see each other, and where we came from, we might all get along better.

So that's the real point of my book: to tell you what I've seen, how an underdog can prevail, and how I learned to have respect for all different upbringings. I'll

start by saying that there's a reason not a lot of this shit has been written about before. That's because very few people make it from tiny cities to the big ones. People from Naptown are hardworking, industrious folks who have big dreams of traveling the world and having nice things. A lot of people I knew from back there who got rich made their money in the streets.

I tried hustling, but I failed at it. Early in my comedy career, my first manager, Dave Klingman, called me "an unsuccessful thug," and he was right. You'll read all about my life in crime;* you'll see that I couldn't shut up when I was robbing a drug dealer; you'll hear about the time I couldn't get past a guard dog when I was burglarizing a house. I went to jail so many times that my brother told my mother I was doing it on purpose. An OG gangster told me in the streets one day, "You're too sensitive for crime. You gotta be born with this."

I often think that if my heart had been just a little bit colder, I would have stayed back there. And I would have died there in the streets.

Maybe you can tell from the subject matter: Writing this book wasn't easy for me. From when I was a little

* Quick note for the Indianapolis PD: Hey. This whole book is a product of my imagination. Any similarity to crimes solved or unsolved would be purely coincidental. Cool? Cool. Also, to friends from the neighborhood pissed you're not in here by your right name: Sorry. Giving you fake names was easier than testing statutes of limitations.

boy, I saw fucked-up shit—shootings, ODs, rats attacking babies—that still gives me nightmares.

And I feel guilty for being alive when so many of my friends are dead, buried back in Indianapolis, in Crown Hill Cemetery.

My time hasn't come yet. I'll see them again.

But why did I live and they didn't?

I went to a therapist once, years ago, when I was starting out in show business. She said, "What makes you different from other people, Mike? What makes you special?"

I shrugged. I didn't have an answer for her then.

Now I do.

I get my strength from Naptown. Being from there makes me *special*. And what makes me *different*?

I got out.

ARCHANGEL MICHAEL

Cornfields. *Hoosiers.* The Speedway. Lake Michigan. Notre Dame: That's what you think of when you think Indiana, right? But in the center of that state, slap in the middle of the biggest city, shit gets *real.* Being a black man in Indiana, it ain't no joke.

I'm from Naptown. Not Indianapolis—we call it *Naptown.* Mapleton–Fall Creek, a couple miles north of the city center, was my neighborhood. I've always thought of it as a place designed for people like me to fail. Where I lived on for a lot of my childhood was around Central Avenue, Ruckle, Carrollton and Twenty-First, Carrollton and Thirty-Third. Dirty-Third, we called it.

In the 1950s, black people with decent jobs moved to Mapleton for the trees and the big-ass houses. Four,

five bedrooms, sand basements. A lot of house for your money. It was a nice black middle-class neighborhood.

By the time the 1970s came along, a lot of the place was on fire. There were tore-down houses, empty lots. You could walk down one street and see through to the next street over. The blocks looked like they had missing teeth, know what I'm saying?

Some of the houses had full families, though mostly it was single moms with their kids. There were still some middle-class people here and there, but the rest of us were so poor we thought anyone with a color TV and a car that ran was ready for *Lifestyles of the Rich and Famous*.

I was born Michael Elliott Epps on November 18, 1970, at a city hospital called Methodist. And, boy, the way my family tells it, I came out struggling. I had the umbilical cord wrapped tight around my neck, so tight it almost killed me. I was a vegetable for a little bit. Maybe that explains why I'm a little crazy. *Shiiiit.*

Even though I was born so small and so blue, my mom fought for me from the first second. "Don't you give up on him!" she yelled at the doctors. "Look, he's still alive! We're going to give Michael a chance."

It took a couple of days there, but I came around.

"See?" my mom said to anyone who would listen. "I told you all he's a fighter."

That's when I got my reputation for being a survivor. To this day, my mom likes to say I had two birthdays. The first was the day I was born. The second was when I opened my eyes and looked around and everyone started to believe that I might live after all.

That's my mother: Mary Reed. Ms. Reed to you. Most beautiful woman in the world. One of those women everyone just wants to be around. Always popular with men, for sure. A great cook.

Also, I get my humor from my mother. She is the funniest woman in the world. She's got this sarcasm about herself, you know. And she kept the family going no matter how bad things were. And things got bad as hell, as you'll see.

My mom was born in Indianapolis, one of ten children. She was the oldest and so she had to take care of all nine of her brothers and sisters—have them dressed, clean, ready to go to school, back home, dinner, bed— because my hardworking grandmother had two jobs. My mother was like a grown woman at thirteen, fourteen years old. You know what I mean? It was straight adult shit from the start. She had it bad as a kid; we all know bad shit happened to kids back in the day. And then she went ahead and started having her own kids before she got to see much of the world, before she could find out what she wanted to do, before she could use her talents.

Instead, she ran away from home a couple times. She married her first husband to get away from her family, who definitely showed tough love. So my mother definitely never got to dream big or even really to have any great fun—I feel like she never did feel free or hopeful, you know?

But my mom was strong. She'd never want you to feel sorry for her. My mother—and I always take my hat off to her for this—kept it together. I didn't find out about a lot of the worst stuff from her childhood until I was an adult. I look back now and I think it's a miracle that she was able to do so much for us, with all she had going on in her head. I'm really amazed that she had such a love of life, given what she had to deal with.

There were lots of great things about her. She really loved music—my mother used to listen to everything, from Marvin Gaye to Gino Vannelli to Barry Manilow. And she was a reader. My mother's imagination was crazy. In fact, her imagination is one of the things that I got from her. My mother was a woman who traveled the world without leaving Indianapolis. She has been everywhere and ain't been nowhere. You know what I mean?

Bottom line: My mother has always been very, very smart. We knew this from an early age because she was great at *Jeopardy!* She'd sit there on the couch yelling

out, "What is Greece?" "What is Shakespeare?" "What is the Declaration of Independence?"

We'd ask her, "Mama, how you know all them answers?"

"I used to go to the library and read a lot of books," she'd say. "You should, too . . . Wait . . . What is Persian?"

My mother's secret dream—well, not secret now, Mama!—was to be an interior decorator. She could make a house real nice on no money. She would buy a couch that was old, or ride down the street and see a couch that was sitting on the side of the road and grab it and go get it reupholstered, so it looked like we had new furniture in our house. She'd make curtains and pillowcases. She loved flowers and for things to look pretty.

And, man, she worked so hard at everything she did, every job she had. When I was a kid, she worked at a department store called Block's and got promoted all the way up to sales manager. With the money she made when I was little, she bought a blue Ford LTD with a white top and white leather seats. Man, I was so proud to see my mother roll up in that car, bought with the money she had earned.

But her whole adult life, and for all the jobs she's had, she's mostly just been our mama. She loved her kids more than anything, and she fought to give us a chance in life even though we were surrounded by bad shit and

not a lot of people got out of our neighborhood and made anything of themselves. She was a tough lady. I have so much pride in her. I don't know anyone stronger.

I mean, in those early days, even when we only had pennies, my mom never made us feel like we were *that* poor. A bowl of food would land on the table and I couldn't even figure out how she got it there. To this day, I don't know how she put together those meals while taking care of five kids and working. We ate a lot of spaghetti, because pasta fills you up and gives you energy, and it goes a long way. Plus, she'd always find some way to bring home a treat, like candy apples. And she'd put on some old-school music and sing along.

When I felt bad, nothing made me feel better than my mom holding me. It was almost worth it to get sick, because she'd take such good care of me. To me, she was magic, know what I mean?

Tahani was one of my favorite aunties. I was really spoiled by her. She was the rebellious bad one and skipped school. I looked up to her. When we got old enough, she would shoot dice with us, take our money. Each one of my uncles served a purpose. Uncle Charlie was one of my uncles I played sports with. He played football and was really integral. My uncle Ricky was in a band, Ebony Rhythm Funk Campaign. They were famous in my hometown. When we had family gatherings,

he played the music. He was a big inspiration. My dad, Tommie Epps, was a transplant to Naptown from North Carolina. He was a great man, a hardworking man—he was *the* man. He worked at the tractor company International Harvester for forty years. Perfect attendance.

My mom and dad weren't married. Hell, according to my mom, they weren't even around each other enough for her to get pregnant. She joked that I was an immaculate conception. She was a Jehovah's Witness, so even early in childhood I had an idea of what this could mean.

"Your name is Mary," I said, "and I was an immaculate conception. You know what that means? I'm the second coming! Why didn't you name me Jesus?"

This got my mom laughing.

"Because you're not the son of God," she said, "just an archangel."

Archangel Michael, if you don't know, is a powerful-as-hell guy in the Bible. He's the angel of protection, a warrior, always carrying a sword. The name Michael means "he who is as God." It doesn't mean I *am* God, but it's still a pretty good name, you feel me?

Though my dad, Tommie, was *the* man, he wasn't *the* most available guy. For most of my childhood, he wasn't around much. I asked my mom about him all the time, so much I know she got sick of it. I always wondered if they didn't last together because my mom was still a

little bit in love with her first love, Robert Hunter. He had been her childhood sweetheart. She'd married him when he was twenty-one and she was twenty. Robert was a military dude, a strong guy, who had been to Vietnam a couple times. He had seen some things, you could tell. They'd had three kids together before they broke up and my mom got with Tommie. Robert was the father of my big brothers, Robbie and John, and my big sister, Julie.

We kids all fought about whose dad was best. To be real, I loved my dad a lot, but I could see that their dad was pretty great, too. And as kids, we talked about our suspicion that my mom loved Robert best. After they'd been apart awhile, Robert even told me: "I still love your mother. I wish I could get my family back."

Robert would come over to see his three kids sometimes and I'd get to hang out with him, too. It was kind of like he was an extra dad for me, and my dad, Tommie, was an extra dad for them. It could get confusing sometimes—so many kids, so many dads. Once, I even got in the wrong dad's car by mistake, and no one even noticed until we were a couple of blocks away.

I sure did look up to my older brothers and sister. Robbie, my oldest brother, was into martial arts. He was also the first guy I ever saw riding a minibike and wearing Converse sneakers. I think he invented that look, actu-

ally, and everyone who does that now should be paying him royalties. Man, when I saw him in that getup, I thought, *That is the baddest dude in the world right there.* But he wasn't a fan of mine—I always thought it was because I had this great head of curly hair and he didn't.

My sister, Julie, oh, she was like my second mama. When my mama wouldn't give me what I wanted, I went to Julie. She and I were closer than she was with any of the other kids. She was always very special to me. I'd follow her around all day, and I used to cry when she left for school.

When I was a little boy, like two years old, and it was time for us all to go to bed, I would cry until she let me sleep in her room with her. She was the only girl, so she had her own room, but I always wanted to sleep there with her. I'm sure she would have rather just been by herself for half a minute, but she would never tell me no. I'd get in her bed and sleep so well. Of course, I was in diapers, so plenty of mornings we'd both wake up soaking wet because I'd peed the bed.

"Why don't you sleep in your *own* bed for once?" Julie would say, all annoyed, changing the sheets.

But still, she never turned me away. She called me "the precious one."

Julie would play songs for me sometimes, because

like our mama I loved music so much. She liked old classics, too. And there were some songs, every time she played them, I'd cry. One was called "Betcha by Golly, Wow" by the Stylistics. Man, that song would kill me. It's so fucking sweet. Every time Julie put that song on, I would bust out crying by the second verse, the one about the falling star and the rainbows.

Julie would say, "Oh, baby, what's the matter? Is this song too sad for you? Do you want me to turn it off?"

I didn't even know what was the matter. That song was just so pretty. Romantic and beautiful. It filled me with so many feelings, you know?

For a while, in the very early '70s when I was real little, Julie would take us to day care on her way to school and pick us up on her way home. I look back on it now and think I should have been nicer to Julie. She was so good to me even though I know I was annoying. Like I shouldn't have played so many pranks on her or tried to get her in trouble. One afternoon, I saw Julie out on the sidewalk, leaning into a car, holding my little brother's hand. In the car was a guy from our block that I knew she had a crush on. Maybe I was jealous because I wanted her attention; maybe I was worried she was going to run off and leave us. I don't know what it was, but I ran back in the house and told our mama, "Mama! Mama! Julie's sitting in the car—with a bunch of men!"

Now, why our mama believed me, I don't know. She really should have known by then that I lied all the time. But she bought my story. When Julie came back in the house, she caught hell. Our mom wanted Julie to stay out of trouble, I think, not end up with ten kids by the time she was twenty. Julie was really a good person and smart, but our mom was scared for her because for everything tough we boys dealt with, girls in our neighborhood had a whole extra set of problems.

Then there was my older brother John. Man, my brother John, he was always shorter than me, even when I was born. It seemed like it, anyway, but John was always my bodyguard, you know? John was my brother that always gave me my confidence to do anything bad. To be funny, to act the fool, or whatever. He had my back. He was real protective of me.

So those were my three older half siblings. My only full brother or sister was my younger brother, Tommie Jr., nickname: Chaney. My mom called him that after an Aretha Franklin song she loved, "Chain of Fools."

Chaney was my first fan. He was also my sidekick and my best friend. My mom dressed me, John, and Chaney all alike in Garanimals shirts and those fucked-up Toughskins jeans with the built-in pads in the knees. Those clothes were sturdy, and we could share them because we were close to the same size, but we hated them.

Chaney and I were together so much, I think people thought he and I were the same. But we weren't. I was naughty and Chaney was always a good kid. Smart. Shy. Good student. But sometimes he went along with my crazy plans and ended up in trouble, too.

Here's an example: Chaney loved that 1970s PBS TV show *The Electric Company*. People don't remember what a big deal it was, but the cast included Bill Cosby, Morgan Freeman, and Rita Moreno. They'd teach you spelling and reading and stuff, using skits.

Chaney loved Mark, played by Morgan Freeman. He wanted to dress like Mark and talk like Mark and be Mark. So one day we're about five or six, we're walking down the street, and I say, "You know what Mark do?"

"No," says Chaney. "What does Mark do?"

"He keeps a bean up his nose."

"He what?"

"A bean. He sticks it up his nose and just leaves it there."

"No way," Chaney says.

"Yeah," I say.

"I don't believe you," he says.

"Fine, don't believe me," I say finally. "All I'm saying is, if you *don't* want to be like Mark, don't put a bean up your nose."

You can guess what happened next—Chaney went and found a bean and stuck it up his nose, just like Morgan Freeman didn't.

Of course, when Chaney tried to take the bean out later, he only pushed it further up. And again, days later, he tried to take it out, and pushed it further still. Eventually he had to go to the hospital to have this fucking bean removed from his nose.

"What the *hell* were you thinking?" our mom asked Chaney once the bean was out.

"Yeah," I said, nodding along with my mother, "that was really dumb, Chaney."

"You told me to, Mike!"

My mother shook her head sadly. Again, why my mom took so long to catch on to how much I lied, I don't know. Like I said, I was bad. Couldn't help it. But Chaney kept hanging out with me. Because I may have been bad, but I was also fucking *fun*.

One day when I was around seven, we were visiting at our dad Tommie's house and I convinced Chaney that we could drive our dad's truck, which was parked in the driveway. So when our dad wasn't paying attention, we got in.

"Hey, Mike, I don't think Daddy gonna want us to drive this truck," Chaney said.

"It's just in the driveway," I said. "Trust me, it's cool. We gotta learn to drive sometime, right? Why would he leave the keys in there if it wasn't okay?"

"I don't know," said Chaney.

"He's not gonna say nothing," I said. "And if he does, you know they won't say nothing to you, Chain Brain, 'cause they like you better."

Chaney had to agree. Everyone did like him best. He was quiet and smart, while everyone thought I was a little crazy.

"I don't think it even runs, so it probably won't even come on," I said. "Look, I'll even put my foot on the brake while I take it out of park."

So I started the truck—and drove it right into the garage door.

My foot wasn't pressing on the brake—it was on the gas.

Right away, our dad came running out of the house.

"What the hell?!" he yelled.

"I know!" I said, standing by the dented garage door. "I don't know why Chaney did that. He's crazy."

"Chaney!" Dad yelled. "I would not expect this of you!"

"It was Mike!" Chaney yelled. "It was Mike! C'mon, you know it had to be Mike!"

At least we both got in trouble that day, but poor Chaney . . .

Sorry, brother.

Most days that we were not winding up in the hospital or driving trucks into doors, Chaney and I went for long walks looking for adventure. In our neighborhood, we saw a lot of fucked-up stuff. Not a lot of good role models out there, you feel me? But to us the local crooks and homeless guys and winos became characters in the show that was our life. And Chaney would draw pictures of everything—he was a real good artist from when he was little.

Me? I was a good *talker*.

Chaney and I always explained away the stuff we saw, good or bad, by telling each other stories about people on TV, like from *The Muppet Show* and *Sesame Street*. We would blend those characters with people from our neighborhood.

"Hey, man, did you hear?" I'd say. "Bert went to jail last night."

"Oh, yeah?" Chaney would say.

"Yeah, man. They pulled Bert and Ernie over. They let Ernie go. But I think they found some weed in Bert's pocket."

"What you think they're gonna do to him?"

"I dunno. Mr. Snuffleupagus might go down and make his bond."

"What else been going on?"

"Oscar the Grouch and Gonzo got in a fight over Miss Piggy in a parking lot. Gonzo went to the hospital."

"Dang! What else?"

"Big Bird finally got that money he been waiting on. He sued Ronald McDonald because they had the same beautician."

And we could talk for hours about the Count. With the cape? Always counting his money? No one had to tell us twice that he was a pimp.

"The Count, man," I'd say, "he starts throwing $50 bills in Big Bird's face, right?"

"Oh, Big Bird doesn't like that shit," Chaney would say.

"That's right. The Count goes *vone, vtwo, vthree,* and BAM! Big Bird shot him."

Chaney and I could do that for hours upon hours. We told so many stories, it could have been whole seasons of a cartoon cop show.

And I was always looking for new material. My mother used to tell us, "Don't go over on that next block!" but I couldn't stay away. We could see people selling heroin and weed or hookers leaning into cars, just on the block over from us. I used to go over there and just find somewhere to sit and watch the hustlers running to the cars and police locking them up and chasing them and the shoot-outs and the fights.

I'd go home and replay everything these muhfuckas

did, but with my toys. I'd turn the corner of the wall into the liquor store. A little Matchbox car would pull up on the corner. A little army man would say, "What up, man? You got what I need?"

If you were on the outside watching, you'd just see a cute little boy in the corner playing toy cars and talking to himself.

How cute, you'd think, *he's playing with his little toys.*

Oh naw—those little action figures were doing drug deals, having sex in alleys, holding up stores.

One of my favorite places in those days was Bradley's Candy Store. Mr. Bradley was a seventy-year-old black man who had been part of the Great Migration back in the day and come up to Indiana from Nashville. He owned a lot of property, including taverns and liquor stores. He was the first black entrepreneur I ever saw. I tried to model myself after him. He'd take me with him to the dog track sometimes, and he'd insist I wear a suit if I expected to ride in his Cadillac. My friends didn't understand why I wanted to hang out with an old man for. They didn't get that I was learning things. I was soaking up some game. He taught me how to play cards, like one eleven-card game called Coon Can't—"Because some coons can and some coons can't," said Mr. Bradley.

Now I know that this was the beginning of me in both crime and show business. I thought those guys

were fascinating and I wanted to try doing what they did, making money just from hanging out on the right block. I also got to copying what they did and just enjoying what it felt like to play the role of the dealer or the hustler—do their voices, learn the things they said, the way they moved. Always, I could make nothing into something. I could make *anything* into something.

Here's one: When I was maybe eight, my brother Chaney and I started a crazy fad in our neighborhood. I really loved dogs, always wanted one, but it took a while before my mom said yes. So while I was waiting for my dog, one day I got a log from the firewood stash someone had given us and I put a leash around it, and then I went out and walked my tree-log dog all around the neighborhood. People looked at me like I was fucking nuts. ("Must have been that umbilical cord: scrambled that boy's brains.") But it was just me making something out of nothing, and it was fun. Then Chaney got himself a wooden dog, too, so now there are two of us walking logs on ropes around the neighborhood.

I had another best friend in the neighborhood, Ryan Bembry. He was littler than me, but he was still my bodyguard. He'd kick anyone's ass—his granddaddy called him Ryan Heart, like Lionheart. He got himself a log and a rope, too, so now there were three kids dragging log dogs around.

Well, word spread. Before you knew it, every kid in the neighborhood has a log dog. You got all these kids walking around, dragging pieces of wood, naming them, talking to them. It was better than Pet Rocks, because those wood dogs were heavy, so you'd have fun and get a workout, too. And this was how you made something out of nothing.

As we got older, my brother and I watched the same lineup every night: *Good Times*, *The Jeffersons*, *All in the Family*.

My mother liked classic television, like Lawrence Welk, with the bubbles and shit. Mary Tyler Moore. Bob Newhart. Those were her characters, and I think she found those shows inspiring. She wanted her house to look more like those houses, and her clothes to look more like those clothes. Like I said, she was a very classy lady.

Television is one of the places where people like me learn shit, where they learn about America. America taught people in the '60s, '70s, and '80s—through TV— how to look, how to act, how to be. (Reality shows do that now, I guess, so I guess that's why we dress like shit now. Back then, the people on TV were aspirational. They wore pantsuits and had perms. Now? Oh naw . . .)

Our favorite show when we were kids, though, was *Diff'rent Strokes*. Chaney and I could relate to those two kids so much. And we saw that they had it good. We

would say: "Mama, we want to go live with a rich old white man!"

We really did, too. We wanted to live with my guy Mr. Drummond. We talked about it all the time.

"Imma tell you something," our mom would say. "At least you know your mother and father. Those kids' parents *died.*"

Then there were commercials. So many good ones! Chaney and I made long lists of all the shit we wanted: Motorcycles and leather jackets. Big Wheels. *Star Wars* shit. Board games. Slinkies.

We couldn't afford any of it, but one day, we knew—somehow—we'd get it all. We'd daydream about what it would be like when we struck it rich.

All us kids loved TV, but I think I loved it the most. Starting when I was just a few years old, I started doing impressions of sitcom characters and of the people in our neighborhood. Honestly, I think the people on TV sometimes seemed real and the people in our neighborhood seemed made-up. And all of them were fair game for me and my impressions.

"He's a good marker," my sister used to say. That's a word we used for copying: *marking*. I marked everyone in the neighborhood, and everyone in the family. I was really good at it. I was so good at it, people started to notice, and to ask me to do bits. Like, my guy Boo-Boo's

father had a limp and was always shouting, so I'd hobble around shouting, "Boo-Boo!" Everyone would crack up and say, "Do it again, Mike!"

I had a friend named Greg Mack, and his mother's name was Ms. Mack—*Miss Mary Mack, Mack, Mack! All dressed in black, black, black!*—and she used to cuss up a storm. I'd come over to their house, knock on the door, listen to her curse and curse, and I'd take notes so I could do that shit for our friends later.

I had jokes and bits from age six—real jokes. Yeah, okay, some of the bits were a little nasty, like taking my boogers and wiping them on other people's faces. I was a bad kid. Bad, but sweet! I had anger streaks, and crazy streaks, but I've always been a nice guy, too.

"You're a real funny kid," my mom would say.

To me, her laugh was the sweetest sound in the world. I'd do anything to hear it.

2

THE BADDEST KID IN
SCHOOL

Now, my mom loved me, but was she proud of me back in those days? I don't know about that. I was "a real funny kid," but I ran fucking wild. When she was showing off her kids, she'd say, "This is Robbie. He plays football and music. This is Julie. She designs clothes and sews. John does martial arts. This is Tommie Jr. He's an excellent artist."

"And who is this boy over here?"

"Oh, that's Michael."

Just Michael. I didn't do anything she could brag on. I was a damn fool, if you want to know the truth, always raising hell. When I think now about all the ways I found to get in trouble, I can't believe how dumb I was.

For example, one day I wrote down every curse word I ever heard and stupidly left the piece of paper lying around. My mom found it and she taped it on the front door. She told me that if anyone came to see us I'd have to explain it to them. Soon enough, some family friends came over. My mother called me into the entryway.

"Michael," she said to me, "tell everybody what this is. Read the words."

"It's a list of curse words," I said. I was so ashamed I started crying. Through the snot and tears, I read, "*Shit . . . bitch . . . fuck you . . . asshole . . .*"

"What's that one?" my mother said, pointing to a word I'd skipped.

"*Pussy . . .*" I said, sobbing.

You know the worst-behaved kid in your neighborhood, the one everyone would assume was guilty if something ended up stolen or busted? Yeah, that was me. I was always doing stupid shit. Once I threw a heavy film reel up in the air and it came down on my head and split my skull open. In my family, they like to say that was my first time in the movies. I threw rocks at windows. I glued a girl's hands together when she fell asleep. (Don't worry, she got them apart eventually.) I would beat up Chaney all the time. If I got bored in a diner, I'd take the paper off a straw and tear it into tiny pieces and, with

spit, stick them all over my face, like I had paper chicken pox. My mom was always popping me for that shit, but it didn't do any good. If I got a laugh for it, I'd keep doing it no matter what the consequences were.

I was real dramatic about my badness, too. It wasn't like I was a sneak. In fact, I was terrible at hiding things. I got caught for pretty much everything I ever did wrong. And the stupider I was being, the more I wanted everyone to hear about it. Like, one day I got mad about something and went and sat in my bedroom window up on the second floor.

"I'm getting ready to jump!" I shouted down. "I'm gonna do it! Say good-bye to me now!"

"Momma!" Julie shouted. "Michael's getting ready to jump out the window! Come quick!"

"Well, let the damn fool jump, then," I heard our mama say from downstairs.

I guess after five kids you can tell when someone is bluffing a jump from a window. She was right. I didn't jump. All I wanted was attention.

At school it was no different. Our mom was sure glad, I think, to be free of me a few hours a day, to let the public education system do what they could with me. I got in trouble all the time, though, and got sent home plenty. Every single year, I was the worst kid in class,

and my mom heard about it. I don't know that they had speed dial back then, but if they did, you better believe the principal had my mom on it.

My mother would have to drag me out of bed in the morning to go to school. I hated school. I mean, at first I liked my elementary school pretty good, School 48. School 48 was a cool place, man. I remember on Fridays when they would let out, they sold real good popcorn. I loved that popcorn. If I close my eyes, I can taste it now . . . *Mmmm* . . . *That* was worth showing up for. But the rest of it? Naw.

Shiiiit, I got left back twice.

I even got left back in kindergarten. Do you know how bad at school you have to be to fail kindergarten?

Maybe it was the umbilical cord thing. Maybe it was the three bowls of Cap'n Crunch I ate every morning for breakfast, which meant I'd be a Tasmanian devil all morning, then crash in first period and fall asleep at my desk. By the time I woke up again, I'd have lost track of what was happening, so I'd just look around, trying to think of shit to make everyone laugh, something to shout out, someone to make fun of. I didn't care if it would get me sent back to the principal's office, get my mom called. Again, if I got a laugh, it was worth whatever happened.

I was always making up stories, telling jokes, trying

to get everyone to crack up. Schoolwork was boring, and math was fucking impossible. So instead I'd spend my days trying to think up pranks. I'd put tacks on kids' chairs, make funny noises, shout things out of turn.

I really don't know why I was so bad. I've just always been a mischievous guy. And I can't control my mind sometimes. I can't help what I think is hilarious. All I know is that at school every day was a new challenge to be badder than the day before. Usually it was just for a laugh and no harm done.

A lot of the teachers actually liked me and thought I was funny, even though they still failed me. Not all of them liked me, though. Some of my teachers hated me and told me so, too. No joke. They wanted me to suffer. I know this because they said so.

There was an evil teacher at my school, a rough little woman who could not wait for me to get in her grade.

"When you're in my class, I'm going to get you!" she'd say when she saw me around the school.

When I did get in her class, I found out what it meant to be "got." Whenever I did anything wrong, she made me kneel on the floor for what felt like hours, facing the wall, my knees on bottle caps. That was some Guantánamo shit right there, you know what I mean?

But these days I almost feel bad for that evil teacher.

Because if she thought it was going to straighten me out, it sure didn't work. If anything, it made me hate school more. I just got worse and worse, just to spite her, and also because it felt like: Why not? We didn't really have any idea of what we wanted to be when we grew up, what we would want to be good *for*. It's not like college felt like a real possibility for most of us. Hell, most of us would drop out before the end of high school. It's not like we were on the fast track to med school.

You know, when people say, "What did you want to be when you grew up?" I'm, like, "Get the fuck out of here. That is a white-people question." We didn't have goals where I came from. There weren't any kids saying, "I want to be president!" "I want to be a pilot!" "I want to be . . ."

Oh naw. We wanted to get some money, and we wanted some new Jordan sneakers, and we wanted to not die. That was as far as we were thinking ahead.

No one really seemed to expect anything from us, you feel me? I feel like the whole world—and for sure all the white parts of Indianapolis—just hoped we'd stay in our neighborhood and not come bother them. People blame poor people for not pulling themselves out of poverty, but how you going to pull yourself out of it when you can't even imagine what it would look like? It's not as if we had an uncle who was an astronaut or

a neighbor who was a professor or a cousin who was a banker. We knew people who worked in factories and people who worked at fast-food restaurants, and plenty of people who didn't work at all.

But there was at least one day a year when the white part of the city pretended to care about us: Career Day.

It was a joke, of course. For a couple hours once a year, some poor sap came to talk to us in a loud assembly no one paid much attention to. In theory, they'd get firemen or cops or doctors to show up and talk to us about life and their jobs and we'd get inspired and choose to not become drug dealers.

Right-o.

One year, the guy who came to talk was introduced to us as "Officer Friendly."

There wasn't nothing friendly about that motherfucker. He should have been called Officer Drew the Short End of the Stick and Had to Go Talk to Hood Kids, or Officer Irritable, or Officer Let's Get This Over With. He came down to the school, sat in a chair in front of us, and talked to us kids about his job and about how the law is good and a lot of other things that sounded pretty far-fetched. Some brownnoser kids raised their hands and said they wanted to be cops.

Oh, come the fuck on, you do not, I thought.

Then came the Q & A part.

"What's the scariest thing you ever had happen?"

"What's it like chasing bad guys in your car? Do you get to drive fast?"

"Do you have a police dog?"

"Do you really eat donuts?"

Ha-ha.

Then it's my turn to ask something. You can guess my favorite question: "You done killed somebody?"

"Oh no," Officer Friendly said with a little chuckle. "We're not going to talk about that today."

I raised my hand again. I had some more questions, mostly about guys from my neighborhood.

"You know Dominic Amy?" I asked.

I saw the cop flinch.

Dominic Amy was a bad muhfucka. I *knew* he knew Dominic Amy, aka Big Sweets.

"Why, yes," the cop said, looking uncomfortable. "I do know him. How do *you* know him?"

"Dominic don't know me," I said, "but I know him 'cause he's from the hood, too. I know some other people, too, who you might know." I listed a few more names. All, I bet, on his most-wanted list.

"Well, that's a real Indianapolis Who's Who!" Officer Friendly said. Then he joked to my teacher, "He's pretty interesting, this kid here." He was probably mentally measuring me for an orange jumpsuit.

"That's enough questions from you, Michael," the teacher said.

The cop said I didn't need to know Dominic Amy and those other guys, that I should stay away from them, that I should think about becoming something good, like a police officer, that I should work hard in school and play it straight and I'd get to be like him when I grew up, not in prison like those other guys would be one day if they weren't already.

But Dominic Amy was doing more than all right, from what I could tell. He commanded more respect on my block than this cop in bad shoes. And you wouldn't catch Dominic Amy having to show up at some crappy school first thing in the morning to talk to a bunch of annoying fucking kids.

What I wanted to say to Officer Friendly, too, was that I couldn't choose not to know Dominic Amy or anyone out there like him. If you lived where I lived, no matter how hard you tried not to, you'd know everything about Dominic Amy, just as sure as if you lived where Officer Friendly lived you'd know all about the president of the United States or Madonna or Tom Cruise.

Plus, when shit went down and I was in some sort of trouble, a hell of a lot more help was available from the likes of Dominic Amy than from any Officer Friendly. And the reality of where I grew up is that if a parent isn't

there every day, hands-on with their kids, those kids are going to venture off and find stuff. And not good stuff. It's not like we'd wander down a dark alleyway and find ourselves accidentally taking an SAT. We wouldn't pass out at a party and wake up wearing a suit and tie on a trading floor.

As the years went by, school got harder and I went less and less. With my dad not being around so much, there was no way my mom could keep an eye on us all the time. She was raising the five of us—me, Chaney, Julie, Robbie, and John—on her own, and just on her salary at Block's department store. There weren't a lot of enrichment activities available. In fact, sometimes there was barely enough food in the house.

Our living situation wasn't always stable, either. We moved around a lot, trying to find a place that we could afford that could hold us all. Sometimes that meant all six of us in a studio apartment. In between those apartments, whenever we got kicked out for not paying rent, we'd put our stuff in storage and go stay at my grandmother's, on Twenty-First and Carrollton, until we were back on our feet.

While we were staying with my grandmother, I switched from School 48 to School 101, closer to her house. Man, School 101 was the *hood* hood. There were some hard fucking kids at School 101. I had to learn

fast how to survive there. My secret was to act cooler and harder than everyone else, even though inside I was scared.

The key to my tough persona was smoking. My mom caught me once when I was about nine teaching myself to smoke in the basement. She said, "I'll tell you what. You stay in the basement and smoke the whole pack until you finish it."

It was nasty, but I sat down there and smoked my fool head off. I was coughing, crying—it was terrible. But it was kind of like smoking boot camp, and I learned to do it without gagging after that. And that's how I became a smoker.

So at 101 I was able to impress the fuck out of other kids. Some bad muhfuckas would come up on me and I'd just lean back like I wasn't intimidated at all. Then I'd pull out a cigarette and start smoking. I wasn't even ten yet, but I was a guy who'd lean against a wall and smoke. They were fucking impressed. At that age, kids say, "Damn, he's a real bad boy!" and then they listen to you. People didn't fuck with me. They looked at me like a leader.

Once, a neighborhood kid stole a couple of younger kids' bikes, including my brother's. These little boys were tough, but they didn't know how to get their bikes back. As the older and wiser "man," I gathered them

around me in the backyard, lit my usual cigarette. I was a military commander. I had to give them a plan to get those bikes back, and also make them feel like they had the power to execute it. I thought long and hard while they stared at me.

"Go get your bikes!" I said finally.

They stood there for a second and then ran out of the yard.

An hour later, they came back with their bikes. They were a little worse for wear, but they looked proud of themselves, and I was proud of them, too.

That said, I mean it wasn't like some of my friends weren't bike thieves, too. One kid I knew thought of nothing but bikes—which were the best ones, how to steal them, what he could sell them for. In fact, he never made eye contact with anyone, ever, because he was too busy looking at bikes.

Big Black Stacy. Little Poker. Julio. Fatso. Mike Jones. Flea. Little T. Big Ellis. Shaky. Big Man. J-Dawg. Red. Junie. Fat C. LaDon. Rico. My mom didn't like the looks of some of them—she thought Fatso, especially, was bad news. My mother told me many a time, "Leave that little boy alone. He gonna get you in trouble."

I should have listened to her, but there was a problem: They were the most fun to hang out with.

Even when I did get in dangerous situations, I almost

always seemed to find ways to wiggle out of them. There was one day when a couple of older boys were picking on me at 101.

"You better stop picking on me," I said, "or I'll sic our dogs on you! We have seven Doberman pinschers!"

When they didn't believe me, I went and got my brother John.

"These are the guys picking on me, John," I said. "They don't believe me that we have dogs. Tell them we have dogs!"

"We have dogs," John said, like the good brother he was. (We had no dogs.)

"Dobermans?" a kid asked.

"Sure," John said. (Across the street from our house were a couple of biker guys who had two Dobermans. In the early '80s, those dogs were very popular. It was a good lie.)

"But do you have *seven* Dobermans?" one of these kids said to John.

John raised his eyebrows and looked over at me. He couldn't quite bring himself to say yes, but he shrugged. He let it ride, letting them believe it if they wanted to.

"Whoa!" the kid said. "I guess we're not following you home after all!"

On our way home from school that day, once we were out of those kids' sight, John started laughing.

"What?" I said.

"*Seven*?" he said.

Hey, if you're going to lie, make it good, right? I think I was a good storyteller because I didn't ever go halfway. I went all out.

"You don't just tell a lie," my brother John said to me. "You always tell it and then you *paint* it."

Looking back now, I wonder if I was so bad because I was sensitive and all the bad shit around me was piling up in my kid brain. And I wonder, if I'd had more stimulation and more education and more attention, whether I'd have been so restless. I felt like I needed to be popular or I'd get beat up, not be safe. I was too shy to really show people my true self, so I just said, "Fuck it, I'm going to be bad." My only way to get attention was to be bad, talk about people, say shit.

Deep down, I spent a lot of time hoping things would get better somehow. I wanted so much for myself and for my family. I wanted new toys, and nicer clothes, and better food. I wanted our mom not to be so tired and to get a nice, permanent house like she wanted.

See, my mom had a dream. She wanted a house of her very own, big enough for all of us, full of light. She wanted the house to be clean and comfortable. She wanted to fill it with nice furniture and pretty curtains. And she even wanted to put a white picket fence around

our yard. That fence would show the neighbors that we were living right, and in her mind I think she thought it would keep the bad parts of the world out and her kids safe.

Little did we know, she was about to get her picket fence—and it would ruin our lives.

3

THE HOUSE AT CARROLLTON AND DIRTY-THIRD

So there was my dad, Tommie, who I shared with Chaney, and then there was Robert, who was Robbie, John, and Julie's dad, and sometimes they would visit at the same time, and sometimes when they did, they were a little bit wasted and feeling emotional.

Awkward—two drunk men in the driveway, both yelling for their kids. It looked like a cabstand at the end of the night. Sometimes they would throw punches at each other because they were both still in love with my mother.

We didn't care if they were drunk, though. We all loved our dads, and one another's dads, too. Both our dads treated us all equal, as if we were theirs. (My dad

always said Julie was the daughter that he never had.) Still, all us kids thought, when it came down to it, that *our* dad was the toughest, the smartest, and the strongest. We could argue all day about it.

Chaney and I would say Tommie was the best. Julie, John, and Robbie would say Robert was the best.

After fighting about it for hours, we'd ask my mom to break the tie.

"Ain't neither one of them shit!" she'd say, like Judge Judy.

Then one day a new guy came along, Reggie. A nice guy, younger, lots of energy. My mom always liked younger men, and they liked being with a confident, pretty older lady.

Usually I didn't like the guys my mom brought around besides Tommie and Robert. All I knew about them was they always ate our cereal. But this Reggie seemed like a good guy. And he fell in love with my mom. He was a good-hearted dude, and he wasn't only nice: He also had a good job working at a publishing company. He even liked us five kids and seemed okay with being a stepdad. He was the answer to my mom's prayers. And it just kept getting better.

"Quit your job!" Reggie told my mom. "I'll take care of you and your kids."

That was a bold move right there. Five kids, and

there Reggie was, saying he'd take responsibility for all of us.

Eventually, Reggie and my mother got married and had two boys of their own, our little brothers Aaron and Nathan, whom we all loved.

Man, those were some flush years. My mother would take us to Reggie's job on Friday to pick his check up and then we'd go grocery shopping. We had food in the house, and Reggie seemed to make my mom so happy.

I say we were flush . . . Actually, we had enough, but never extra. I was bad at math, but even I knew that seven was a lot of children to feed on one paycheck. The second food hits the table, everyone's racing to eat as much as possible as quickly as possible. When you have that many kids in the house, it's like the real *Hunger Games*.

If we ever came into possession of any kind of treat, we would have to eat it right then, even if we weren't hungry. You can't hide candy when you're surrounded by that many kids, because even if you come up with the most brilliant hiding spot in the entire world, someone is going to sniff it out.

My brother John once got a honey bun and wanted to save it until after dinner so he could really savor it. Well, we all loved honey buns, so he knew he'd have to squirrel it away if he wanted it to survive in that house

for a few hours. He came up with a pretty good spot: at the very back of the fridge, behind the baking soda.

Well, my brother Chaney and I still found that honey bun way in the back. We had to move about five hundred bottles of expired mustard and ketchup out of the way to do it, but we got it, and it was delicious.

John learned a valuable lesson that day about eating honey buns the second you get them.

By the time I was in second grade or so, Reggie was supporting all of us at a house on Carrollton and Thirty-Third Street. He was a stable father figure, and our actual dads still dropped by sometimes to see us (and to fight over our mom, like always). It was a nice house in a neighborhood full of kids. That was the happiest time I can remember.

Not like it made too much difference to my behavior. I still acted bad. In fact, once I was so bad my family still talks about it all the time. Seriously, if you meet them, they'll say, "Nice to meet you. Did Mike tell you about the bowling alley?"

Yeah, so here's the bowling alley story:

Sometimes my mom or Reggie or the aunts and uncles would take us kids to the Indianapolis airport, because you could watch the planes take off. We'd never been on a plane, so we couldn't get enough of it. Also, they had arcade games and a bowling alley at the airport, so if

we did get tired of watching planes, there was plenty of other stuff to do.

One Halloween soon after my mom and Reggie got together, we got taken to the airport bowling alley. Aunt Angela was the fun aunt. She's the one who took us to the bowling alley. There were a lot of us, so no one noticed right away when I wandered off. There was some kind of tournament going on, money on the line, high pressure. It was fun to watch them getting all stressed-out. I wandered over to the concession stand and watched the guy making hot dogs and pouring Cokes.

Then I found the utility room. The door was unlocked, so I stepped inside. There were a lot of switches and buttons in there. I wondered if this was what it felt like to fly a plane, to man switches. I wondered what would happen if I pulled one . . .

I flipped a breaker. The room went dark . . . and so did the whole bowling alley.

The soda machine went off. The scoreboards. The ball-return system. People started screaming. Someone ran to the room and found the breaker and turned it back on, then found me there, looking guilty as hell. I got perp-walked back to my family, past a lot of people going ape nuts. They'd lost their scores! They'd dropped a ball on their foot! They'd bumped into things! I thought they should be glad that I hadn't hit the airport light

switch instead and made the planes all land on top of each other.

My aunt Angela grabbed my arm and said, "You're going home. That's it!" And the manager of the bowling alley made a big deal of escorting us out.

"I wanna stay!" I begged Aunt Angela.

"No!" she said. "You are going home! All your cousins are going to stay here and bowl as long as they want to, but you are going back home and sitting in your room alone! Because you don't listen!"

I cried and cried as she hauled me back to Carrollton and Thirty-Third.

Reggie and my mom tried to discipline me, for that and for all the other bad shit I did. I was always getting spanked, getting grounded, getting things taken away. Once I laughed at a kid who had gotten burned, and Reggie held my hand over a fire to teach me how much it hurt.

I can't say it made me be better. There were some nights I cried myself to sleep after getting beat. You can argue for or against spanking, but I will say, I slept so well those nights. You sleep like a baby after your mama jumps on your ass. It's better than Valium.

Then came the ultimate you-better-fucking-behave-now moment in my life. When I was in fourth grade, black kids started to get bused from my neighborhood

to a rich white school called Stephen Decatur. An hour and a half each way.

It might as well have been a spaceship taking us to a different planet.

We went to school all day with white kids, and then the bus brought us back to our community and we'd have to make sense of all the shit we'd seen. It was like you were a fucking explorer returning from a trip to the New World. I made a couple of white friends: Tom Roach, Rusty Day, but still, being in that place was discombobulating.

I really didn't know any white people until I went to school with them. I lived in a black neighborhood, and everyone except the cops was black, so until I went to Stephen Decatur I wasn't even really aware of racism because we just didn't see white people that often. My mom did have one white friend she'd worked with, a nice lady named Marci. Marci brought her son, Ritchie, over to play with us, so while my mom and Marci would be talking their girl talk in the kitchen, we kids would be hanging out.

Because Ritchie was white, he was unusual in our neighborhood, so we would bring him out and show him around, like a rare baseball card: "Step right up! Step right up! Here we have . . . a white boy!" Ritchie could hang, mostly, but eventually we would start to

play rough, like swinging off of shit or starting up a game of tackle football, and he would end up running in the house crying.

So it wasn't until I started at the white school that I started to see what growing up black in America meant. I started to realize that kids like my guy Ritchie and I were going to have different sorts of lives. Pretty much the only time white people came in our neighborhood, it was the cops or the fucking fire department. And that wasn't ever a good day, you know? They never showed up to bring us ice cream or tell us how great we were. They were usually coming to take away someone we liked, after they roughed him up in front of us, or to put out a fire.

The idea of the busing was, I guess, to give us poor black kids a shot at what they call a "good education" and to show the white kids how the other half lives or something. I guess they thought it would be good for all of us in one way or another. But I don't know that it worked out like they'd hoped.

The black kids were so confused to be there at all. Back in our neighborhood, we all knew the teachers and we all walked to school. Then this busing experiment started and everything changed. All we'd ever heard about Decatur was that they'd had the National Guard come out because they were burning crosses.

I can still remember the look on the white kids' faces when we showed up. It wasn't like they stood waiting for us with welcome signs and open arms. It wasn't the most inclusive place in the world, you feel me?

Stephen Decatur was basically down the road from Ku Klux Klan headquarters back in the bad old days. (Fun fact: In the 1920s, a quarter of a million people in Indiana belonged to the Klan. To get elected back then, a politician had to have the Klan's support.) Fast-forward to 1980, when Chaney and I and some other poor black people showed up to go to school with those kids' great-grandkids: Well, not a lot had changed. People weren't *saying* they were in the Klan so much anymore, but . . .

It shocked the hell out of me. Up until then I'd hardly left my neighborhood at all. So it wasn't until busing that I'd ever been called a nigger by a white person. But at Stephen Decatur I heard it all the time. Girls, even, would whisper it at us.

The few black kids from my neighborhood who went there locked eyes every day in the hallway, like, *Can you believe this shit?*

That's true anywhere where it's mostly white people. Black people will spot each other and nod. This was different, though: This was basically an all-white school, racist as hell. We had to know where our people were at all times in case the shit went down. We weren't

going to fucking blend in, you feel me? And we were pretty sure things could get real bad any second.

On the other hand, we were pretty excited about some parts of being there. The place was really, really nice—*fancy*. You could tell that school district had a lot of money. The halls were clean, the rooms were bright, the teachers were good, and the food in the cafeteria was *so* good. We saw those lunches in the cafeteria and we were just, like, "Wow." Sometimes it was the only meal we ate all day, so it tasted extra-good to us.

If only they would've done something about all the racist bullshit, it would have been great to be there—weird, but still great. But they didn't do shit; we were expected to just take it. Kids could come up to us, spit at us, call us "nigger," and we were supposed to just ignore it. But I wouldn't take it. I'd get up in their faces, then wind up in the principal's office, and everyone would look at me like I was bad, like I didn't belong there.

"I'm telling you," I'd say to the principal. "Jack keeps calling me 'nigger' when I pass him in the hall!"

"Well," the principal would say, "I'll tell him not to do that anymore. But you gotta just ignore him, Michael."

"We don't ignore that kind of thing where I live," I'd say. "It's disrespectful. I can't ignore that."

Those boys never got in trouble for doing what they did to us. But if we stood up for ourselves? You'd think

we'd killed someone. That's why I got kicked out and suspended a lot. It got to where I would bust their fucking nose when they said that shit. Then they'd say it more. Then I'd fight more.

I got suspended a lot, man. I got suspended, hell, maybe once a month.

This was back in the days of corporal punishment, so I got paddled by teachers, too. Kids today can't believe it, but back then we got beat all the time. In the 1970s and '80s any adult could spank you, basically, for any reason at all.

So, why didn't I just let it go when I got called a name or shoved by a white boy at Decatur?

Oh naw.

For one thing, I had to go back to my neighborhood at the end of the day. If I didn't do something about being taunted by a white boy, my black friends wouldn't let me hear the end of it.

For another thing, fuck those guys.

Even though I was in trouble all the time, a lot of the teachers at Decatur liked me just like they had at 48, I could tell. A lot of them thought I was funny and charming, even though I was impulsive. And a lot of the girls liked me, too. I was a lover at a young age.

That was my main motivation for going to school at that age: to see the girls. I can see them even now.

This girl named Tracie. Another girl named Shereen . . . There were so many girls that I liked when I was a kid. Now, did the girls like me back? I don't know. I was a little ratchet. I could make them laugh, though.

Then came the greatest news any of us had ever gotten. A blessing. Like a gift from God, my mom got a letter in the mail that said she'd won some money in a sweepstakes.

Holy shit! We had never, none of us, won anything, ever. Not a raffle; not a bet. Our family had the worst fucking luck on earth. But now? Now everything was different. We were winners! Big winners. We were looking at thousands of dollars, out of the blue. We'd have nicer clothes for school. We'd have more food. We'd be able to fix up the house on Carrollton. My mom could even have her white picket fence.

While they were waiting on the prize money, my mom and Reggie took out a loan for home repairs and renovations started. We were so excited watching it all go up. The new walls. Fixed-up attic and basement. We were going to have a *nice* house. We were going to be one of those middle-class families with the TVs and the cars and the clean front yards. I was so proud of us.

The house was getting pretty, just like my mom dreamed, like they had in the old TV shows she watched. She couldn't believe she was finally getting that picket

fence, and it was her pride and joy. Nothing could disturb our happiness now. All the bad shit would stay outside that fence forever.

Do I have to tell you what happened next?

We got evicted.

Mom had put the picket fence around the dream house and had it all decked out and looking nice. And then the bank came and they took it all away.

It broke my mother's heart.

Reggie and my mom didn't have money to pay back the renovation loan. That letter about the money we'd won? That gave my mom the idea to make all those home improvements? Turned out it was a scam.

Reggie and my mother had got some kind of *Reader's Digest* sweepstakes thing in the mail and thought it was real. By the time they understood what had happened, they'd gotten all this work done on the house, and there was no money to pay the loan back. Reggie was already supporting nine people on one salary. There was no way he could afford the payments on the loan, too. So we got kicked out. The door in the picket fence hit us on the way out.

"I'm going to go buy that house for you one day," I swore to my mother as we left. "I'm going to get that house back. Mark my words."

"Okay, baby," my mom said.

She sounded so tired. And I knew she didn't believe me. But in my heart, I knew one day I would get that house for her again. And I'd make it so no one could take it away from her again.

The only place we could afford now was the worst place we ever lived, a real hard part of the city: Thirty-First and Ruckle. It wasn't so far from our old place, but it sure felt far. Back in those days in my neighborhood, you just had to go three blocks over from a nice working-class neighborhood, and *bam*, you were in the *hood*. We went from la-la-la-la-la-la, birds chirping, to dong-dong-dong-dong-dong, dark. On one side of College Avenue there were squirrels and sunshine. You cross over and it's all rats, roaches, and thunder.

There were so many roaches and rats living in the basement, it was like a horror movie down there. One night, the hugest rat of them all actually climbed up on the bed where my mother was sleeping with my baby brothers, bit Aaron, and scratched Nathan in the face.

The house just kept falling apart. The paint, which I'm sure must have been lead based, was peeling. Outside was no better: The street was overrun with hard guys. The side door wouldn't even shut, so anyone who wanted to come in the house could. The only good news was we had nothing worth stealing.

The stress of living there was getting to everyone. My

hair started to fall out in spots. At school they called me Dalmatian.

One night, Robbie got into a fight with Reggie. They were yelling at each other, saying horrible things. Robbie stormed out of the house.

"John," Reggie said when Robbie had left, "you can have your brother's room. Robbie's not coming back here."

Well, that set our mom off. Robbie was, after all, her eldest son.

"What are you doing?" our mom said. "You're trying to get rid of him? Who's next, me? You're going to marry Julie instead, and she's gonna have your next kids?"

"Whoa!" Julie said, totally freaked out that our mom seemed to think she was competition for her stepfather. "I don't want your man. No, ma'am. I gotta go."

She was a teenager by this point, and she moved out the next day.

Meanwhile, my brothers and I were getting bigger and tougher, and running with some rough older kids, a lot of those same guys my mom had been warning us about since we were all little. Reggie started to seem scared of us.

It all came to a head one day when we heard screaming and yelling coming from mom's bedroom. We ran in there only to find our mom on top of Reggie, pinning him

down. We knew they were having trouble and arguing about money a lot, but we didn't know it was that serious.

Turns out, it was really fucking serious.

What happened next is a blur, so I'll just tell you what I remember.

It was the late afternoon and I was getting home from fifth grade. I don't know where all the other kids were. I only remember me alone. As I approached the house on Ruckle, I found my mom out front wearing a nightgown.

She was at the top of the front steps, on her knees, crying.

"Mama!" I shouted, running up to her. "You okay?"

She was crying so hard, she could barely talk. I hugged her and held her.

"Reggie's gone," she said between sobs.

I didn't know Reggie and my mom were having problems to that degree. And I couldn't believe they'd really broken up. Maybe, I thought, it was just a fight. I was sure they'd get back together again.

"He left," my mom said. "For good. And he took everything. Everything!"

I walked into the house—it had been stripped bare. Everything they'd gotten together over the years was gone. All our nice furniture was gone, and Reggie had even taken the fridge and the stove. All that was left were our beds.

Reggie had even taken Aaron, the older of their sons, to go live with him at his new house across town, but he left Nathan, then still a baby, with us. My mom said it was because he thought Nathan didn't look like him.

Mom was destroyed.

Reggie had promised when they got married that he was going to take care of her, take care of all of us, but I guess it got too real for him. Looking back, my brothers and sister and I all can see that Reggie had taken on more responsibility than he could handle. He was a working man dating this pretty lady and then all of a sudden he's tied to this huge, broke-ass family, the older boys turning into hard-core muhfuckas. We'd probably be freaking the fuck out, too, if we were in his place.

Yeah, but why did he take the fucking furniture? That is something I will never understand. That was some cold-ass shit right there. You're getting your freedom, man; can't you get a new couch?

When he left, our mother had a mental breakdown. Our house had gone from nice to just trashed, like a fucking squat. Reggie decided that he wasn't going to give her money for groceries or utilities anymore, either, so we were in a cold house in the winter with no heat and no hot water. My mom somehow scraped up enough to keep the electricity on so we could use a hot plate to warm up water. That way we could each take a little

bird bath once a week. It felt only a little better than being homeless would have. It felt like Reggie basically left us there to die.

Maybe that sounds like I'm exaggerating. But death didn't feel so remote at the time. There was death all around us in that neighborhood back then.

One cold winter day, not far from the house on Ruckle, Chaney and I saw a cab parked but running in an alley called Horseshoe Alley. It was a freezing morning and we didn't know why someone would be down that alley with the doors open unless there was something interesting going on. Maybe we'd see people making out. Or maybe the car was up for grabs and we could take it for a ride.

We walked back there to see what was up.

What we saw was frozen blood on the ground and a dead man lying there with wide eyes. The cabbie. It looked like he had been mugged and shot, then left to die in the cold.

He seemed not to have been dead long, but already his blood had frozen him onto the ice. Chaney and I stared hard at that man's dead eyes, the frozen blood, the way his body was lying there. It was the first dead body we'd ever seen.

It wouldn't be the last.

4

OUR FORTY ACRES
AND A MULE

With Reggie gone, my mom went on welfare. Social workers came over to the house with their briefcases. While they said they were helping us, they also seemed to be torturing her. I hated when they showed up, because it seemed like they were making her beg. She was a proud woman, and she'd worked hard in her life. She'd paid her taxes. It didn't seem right that they would nickel-and-dime her.

"Go play," my mom would say to me when the social workers appeared. But I would stand there in the doorway listening to her argue with them about her checks. "I was getting $240!" she'd yell at them. "Now I'm only

getting $140! I have seven children! How am I supposed to feed seven children on that?"

When you have eight people to feed, that hundred dollars really matters. At the beginning of the month, the fridge is full and everyone's happy. But then comes, like, the twenty-third of the month, and all the food stamps have been spent, or maybe your mom sold some so she could get something else she needed. Whatever the reason, your fridge is bare, and you have to listen to your stomach grumble while you watch McDonald's ads on TV.

At first, I felt embarrassed about being on welfare. For a long time, my brother Chaney and I didn't want the other kids to see when we took out food stamps at the checkout counter. I hated that my mother would send us around looking for the mailman so we could get our check as soon as possible.

But it didn't take long until times got so hard that it wasn't embarrassing anymore. After a while I couldn't afford to feel ashamed; I was too hungry. And I saw that a lot of the older black people around me had no such qualms about taking government money.

Now, if you didn't grow up where I did, you might only know about welfare from the "welfare queen" stories of the 1980s. Was that stigma totally overblown and racist? Yes. Was it 100 percent made-up? No, it was not.

I saw a bunch of grown-ass men out there on the front porch, standing there all day, with no shirt, rubbing their bellies, looking for the mailman. A lot of the people we knew took advantage of the government's help and they never looked back.

Still, I didn't judge them then and I still don't today. They may not have worked a day in their lives, but I still say those muhfuckas deserved that money.

Ronald Reagan was in office back then, so we were hearing a lot about Reaganomics. We didn't know quite what it meant, but we were getting money from the U.S. Treasury at the time, so we began to think of welfare as Reaganomics. And we started to think of Reaganomics as reparations for slavery.

Maybe that sounds crazy, but I think there was something to it. The deck was stacked against us. We were pissed off and we were hopeless. That we got a check now and then seemed like the very least white people in power could do. We had to deal with the legacy of slavery, with getting pulled over all the time by the cops, with the lack of opportunity. Are we going to take that $200 in food stamps? Yes, we are.

I wasn't so good in school, but I remembered one thing from history class: In 1865, General Sherman had a plan to give freed slaves forty acres and a mule so they could have a fresh start.

Welfare, to us, was like our forty acres and a mule. Those checks began to seem like compensation for how hard it was for black people in America.

Of course, President Andrew Johnson eventually overturned the forty acres and a mule program. Welfare hasn't exactly revolutionized the plight of black people today, either. It helped us not die back when we were kids, but I can see now that the system wasn't necessarily good for the black community long term.

You could even say it helped to systematically destroy us.

Welfare provided just enough money to survive but not enough to ever save anything or better yourself. It took away a lot of people's drive to become or do anything, and it never provided a way out of the cycle of poverty. Plenty of people I grew up around were wrecked by growing up in that system.

Being black at that time in Indianapolis felt, start to finish, like a pretty shitty deal. At the white school, I ate a good lunch. But I had to put up with being called the worst names and treated like shit. We wanted the food stamps but we had to deal with the welfare officers who acted like it was all my mom's fault she found herself in this place, raising seven kids alone. Like that was her plan all along, to have all these kids and nobody to help her raise them.

Like it was her fault we got evicted from our house.

Like it was her fault Reggie left.

Like it was her fault her kids were hungry and in trouble all the time.

All she ever wanted was a pretty house with a picket fence around it, a man who loved her, and for her kids to be happy. It just seemed like the world made it so hard for her to have any of those things.

Everything just kept getting worse after Reggie left. We started to wonder how bad it could get and for us to still live. Because if there was no way to make ends meet with Reggie there, you can imagine how it got worse and worse every month he was gone. No food. No heat. We all slept in the same room with a space heater because we couldn't afford to heat the rest of the house.

Not to mention, as mad as we were, we missed Reggie and our little brother Aaron. It sucked to think about the two of them across town in a big house eating well while we went to bed without dinner.

The only good thing about the house the way it was after Reggie left was that, since there was no furniture or heat in the bottom half of the place, we could go down there anytime and breakdance in our winter clothes in the middle of the floor. All our friends would come over and dance around, too, in that cold, empty living room.

We always could make something from nothing.

But step outside the house, and that neighborhood was bad, man. People talk about how great it was back in the old days, because kids had freedom? Or because they played with real toys or outside and not with video games?

To me, it feels just crazy that people are nostalgic about games kids played before video games came along and took over. I'd rather have my kids playing *Grand Theft Auto* in their rooms than doing what we did. As thirteen-year-olds, sure, we'd do Pac-Man and Centipede when we had the quarters, but we used our freedom to play some seriously fucked-up games, too.

Most of them involved guns.

One of them was Russian roulette. We'd get my guy Ramon's dad's .22 pistol, take it to the garage, put one bullet in it, and pass it back and forth, firing it into our heads. We weren't great at math, but we did know enough to invite less than six people to play. And, incredibly, none of us ever blew our brains out.

But it was pure dumb luck. One day Ryan Bembry opened up his back door and fired the gun right out into the yard: *Boom!*

"Huh, I guess it *is* real," Ryan said.

As highs go, the feeling that you might be about to shoot yourself in the head isn't bad. Not quite as good as cocaine, though.

I know because it was around this time that I also found drugs. *Found* is not exactly the right term, though. In my neighborhood, drugs were just there, and after looking at them for a few years I picked them up.

The first time I snorted cocaine was over at the house of a buddy I'll call Jimmy. I was about fourteen. Jimmy was an advanced kid, because his mom was advanced. She had been to prison, and she was a real street woman, but she was fly, you know what I mean? Her house was tore-up but her bedroom was *nice*.

Jimmy lived in a druggie part of town, so no one was surprised when someone showed up there high as fuck, even kids. We'd tease them a little but not mess with them too bad.

"Man, he's live!" we'd say.

Until that one day when Jimmy handed me the coke and I put it to my nose and sniffed. And now the live one was me.

The world changed. Suddenly I felt invincible. We no longer lived in a slum; it was a magical playground. I wasn't a kid with no future; I was the king of the world. I felt free. I felt happy.

Immediately, I took off all my clothes save my underwear. I ran outside on the porch and then I ran down the middle of the street. That was a neighborhood that was so depressed that no one even looked up to see a skinny

boy in his underwear running through the streets. It was normal there.

I wanted that high again, right away, and I took every chance I could to find it. Then I hit a spell with it where it didn't do what it did the first time, so I mixed it with other stuff: I would sprinkle coke into my marijuana.

Back then, cocaine was the only way I could make life feel okay. From the moment Reggie left, I've had an anger in me. Mad at the scammers who sent that sweepstakes letter. Mad at the bank for taking our house. Mad at Reggie for taking the furniture. Mad at the welfare ladies for not giving my mom more help. Mad at those assholes at my school for calling me names and trying to make me feel bad when they had so much more than I did and I already felt like shit.

I hated feeling like I was stuck, like the whole system was set up to keep me—to keep all of us—from ever getting anything nice.

I started to realize that some things in this world are automatic. The sun comes up in the morning. Automatic. Black people—born and raised in *America*—are set up to fail. Automatic. For generations we've all had to deal with the same shit from white people: mistrust, fear, anger.

As a result of what I saw happen to my mother and what I felt in school, I had a rage. And after that, all

white people seemed like authority figures to me. You think white people are nervous to be around us? I guarantee that it ain't nothing to how nervous I am to be around white people. Even if they're not the police, they can *get* the police pretty damn fast.

It was something I'd learn real soon.

5

TO GRANDMOTHER'S HOUSE WE GO

Sure enough we got evicted again, so we moved in with my grandmother at Carrollton and Twenty-First, like we always did when shit got hard.

My grandmother, Ms. Anna C. Walker, was a church lady, a Jehovah's Witness, tough as nails. She worked as a cook at a school for the deaf for forty-something years. It was exhausting work and she worked hard. For years she walked to and from work every day to save money for her family, too. She was no-nonsense.

Anna C. Walker had ten kids of her own, but she also took care of a lot of other people's kids. If you ran into trouble in our family, that was the doorstep you showed up on. She was the matriarch not just of my family but

of the whole neighborhood, and what felt like the whole city. Again and again during my childhood, she was our savior.

My grandmother made a good case for religion. She would always show up when we needed food, and she opened her house to us when otherwise we'd have been on the streets.

But she wasn't just a church person and a very strong-willed older black woman—she was also very talented. She was a baker—she made wedding cakes for a lot of people around the neighborhood—and she also made wine from scratch in the tub. The guys in the hood loved my grandmother's homemade wine.

My grandmother does not suffer fools, either. Maybe it's no coincidence that she is also the one person in our family who has never, ever found me funny.

"Mike just don't seem funny to me," she'll say, even now.

"Oh yeah?" I'll say. "Well, your potato salad ain't that good to me."

Don't tell my grandmother, though, but her potato salad is pretty good. All her dishes are good. She went to Purdue's culinary arts school, so she could *cook*. When you're hungry, anything tastes good, so just imagine gourmet dinners being put down in front of you when you're in that state. Eating was like a religious experience.

My grandmother also fought for us. She was on our fathers' asses on behalf of my mother. My mother was nice and wanted everyone to get along, so sometimes she wouldn't stand up for herself enough. That's where my grandmother would come in.

"We're taking them down to the welfare office!" my grandmother would roar. "We're going to *make* them pay their child support!"

And she would, too. Getting our fathers to pay up wasn't easy. They were good people, but a case could be made that they were also both straight-up drunks. It was a miracle that my grandmother somehow got that money out of them. They even sometimes gave us presents, like new bikes at Christmas.

From as early as I can remember, I wished I had money so I could help my mom out.

I wanted a job at age eleven. No one would hire me, so I'd make my own work. I'd shovel snow, or I'd go to the grocery store and ask old women if I could take their groceries to the car. They might only give me a dollar or two, but at least I made something. I noticed a pattern: I had a natural gift for talking, and the more I worked on my speeches, the more money I got.

My first real taste of money and success was selling candy through what was called the American Youth Program. If you live in a city, you may see kids running

variations on this game: They approach you with a box of candy that they've got at cost and try to sell it to you for a little bit more.

Well, this guy Chuck would take me and some other kids in this raggedy-ass truck to the white neighborhoods to sell candy. (I love black people, but they weren't the best candy customers in the world. They would let you say the whole speech and then not buy shit. White people would feel bad for you and actually spend money, so we went to where they were.)

When we rolled up on a nice-looking house, I would knock on the door and the second it opened I would say my speech, which over time I perfected for maximum impact. This was the final version:

"I'm sorry to disturb you at this time, ma'am. My name is Mike Epps. I'm with the American Youth Program. The American Youth Program is a program that keeps little niggers like myself from stealing hubcaps and breaking into your house while you're at work."

White people *loved* it. White women would call into the house, "Honey, come here and listen to this boy's sales pitch!" Then they'd say to me, "Say all that again for my husband!"

At these houses, I'd peek into the door past the smiling white people and I'd see all that luxury. Plush couches! Spotless carpeting! Marble countertops! Chandeliers!

I would think: *This is what I want to have one day.* I wouldn't even have known some of those things existed if not for that job. You have to be able to see it and touch it to know it's what you want.

Some of my friends weren't hustlers and they'd return at the end of the day with a box full of melted chocolates, but every time I went out, I'd come back having sold out and carrying a wad of cash.

Still, it wasn't enough to keep me from being so fucking hungry all the time. I was so hungry that I started to steal from the grocery store. I tried to be real clever about it, though. No running and snatching. I did it real slow. I'd get a shopping cart and put stuff in it like I was shopping but I'd be eating as I went. I could make a sandwich while I was pushing the cart, or eat a whole bag of chips. All the time I'd be looking at the side of canned goods like I'm carefully checking the ingredients. Then I'd put it back, like, *Nope, too many calories. Not enough calcium.* When I was done, I would just put the cart back and walk out of the store. I think it taught me how to become an actor: You had to be a convincing shopper to get away with it.

A couple times I got caught, though. A 7-Eleven manager caught me stealing cookies. I'd gotten away with it a bunch of times, but not this time.

"What's in your pocket?" he said.

"Ain't nothing in my pocket," I said.

He reached in my pockets and pulled out two rolls of baked cookies.

"Well," he said, "you're going to learn your lesson tonight."

"Why?" I asked.

"Because you're going to jail."

I cried so hard.

I was too young for jail, but when the cops showed up, they took me to the juvenile court on Hillside to wait for someone to pick me up. Hillside was actually on a hill, so that was the nickname for the juvie court. If you were bad, people would say: "You're gonna end up on the Hill." I sat there in a room on the Hill, terrified, for hours. I didn't go to jail that night. I left with a warning and was released into my grandmother's custody. I think they knew her wrath was scarier than anything the judge might do to me.

Over time, I tried to be sneakier when I stole, and I learned to keep an eye out for the cops. Especially Charles Martin, who was about six foot eight. He looked like Rob from *What's Happening!!*

The guys in our neighborhood kept the cops busy for sure. There were lots of gangs in Mapleton back then, especially near my grandmother's house. The 25th Street Cobras. Hoodlumville. Brightwood. 16th Street Cruel

Lives. Haughville. Crewlife. 30th Street. Post Road Cross Town. The Ghetto Boys.

The 24th Street Mad Dogs—they called them 2–4—were from the low-income apartments, the projects in a part of the city near downtown we called Dodge City. That was the most notorious gang in Naptown, dating back to the '70s. They had the most legendary street motherfuckers.

They were supposed to be our enemies, but I'd gone to school with some of the Mad Dogs crew and I didn't want to fight them. My strategy for a while was that I would try to stay friends with everyone. We'd lived all over the whole city, so I knew a lot of people, and I made them like me. I would just not stick around when shit went down. When they all got into it, I'd split, just slide out of there.

"I thought you were with us!" they'd say as they started loading guns and I suddenly remembered something I had to do at home.

"I am! I am!" I'd say, backing out the door. "I'm totally with you! But I got to go! I got someplace to be!"

Where I had to be was always the same place: wherever people weren't shooting each other.

Eventually, though, I learned that even if you didn't want to be a part of it, it would pull you in. One time when we were teenagers, my sister, Julie, and I were in

the car and we got followed by these guys who were after me. They chased us a few blocks until I busted a fast right into an alley and pulled up into a backyard and got my sister to run. She was crying, saying, "You gotta get your life together! This is crazy!"

And I had to stand up and fight sometimes. What happens is you can hold out for only so long and then you realize that if you're not part of a gang and committed to fighting with and for them, you're a sitting duck. I didn't want to, but sometimes you don't have a choice except to defend yourself and your buddies.

The war between the gangs would quiet down and then get bad again. Usually if we were involved, it wasn't about drug turf or any of that, but over a girl, or it was about revenge. One time, the Mad Dogs thought we'd done something and so they shot Robert, my brother John's father, while he and my grandmother were on their way back from the Kingdom Hall of Jehovah's Witnesses.

That's how gangs work in Naptown: You stand up for your friends and sometimes that means going after the friends of the people you're fighting. In the bigger cities, like Chicago, New York, L.A., normally the neighborhoods you're in, that's your affiliation. But in Naptown the gang thing is looser. You don't have to be in a gang there, nowhere near as much as you do in a big city. In

Naptown it was a little easier to stay away from some-
body who doesn't like you. There wasn't as much going
out looking for trouble. But you still had to be on your
guard all the time. You wanted your crew to stay to-
gether so people wouldn't mess with you.

For a while, I was in a gang called the 33rd, which
was like a junior varsity version of the 24th Street Mad
Dogs. My grandmother lived on Twenty-First, so my
friends and I were 21. We called ourselves Jump Street,
after the show and the Indianapolis club. Or we were
the Slaughters, because some folks in that part of the
hood had the last name Slaughter. But we were mainly
2–1. We had love for our neighborhood, and we were
trying to get money and, more than anything, to be pop-
ular with the ladies.

Our colors were red, because we had a hookup in
California with the Piru Bloods (if you know gangs,
that'll mean something to you), so we could get any-
thing we needed from them. (The big brother of the
rapper The Game, Big Fase 100, was a leader of the Piru
gang.)

It turned out my brothers and I were pretty good at
gang shit. For one thing, we had a lot of practice fighting
around the house. We were always beating each other
up, wrestling, knocking shit over. It would start with
one little thing—like "You wore my sweater!"—and an

hour later you're still throwing fists until you were exhausted. I had a special skill to make my brothers laugh right in the middle of the fight.

You know, we didn't realize how good we could fight until we got in a fight with someone outside the house and it was so easy. My brothers and I looked at each other like *Who knew?* After that, we started getting into the street fights. It was hard to avoid them, to be honest: Everyone seemed to want to fight all the time, even when you just wanted to go have a good time.

After school one afternoon when I was about thirteen, fourteen, I was out at the skating rink with my girl and my friend Jeff and some other guys. I'm a really good roller skater, always have been. Jeff was on this whole hyper no-matter-what-we're-gonna-get-our-respect trip at the time.

So I'm skating, holding my girl's left hand with my right hand, and suddenly some guy takes her other hand.

Jeff yells, "Mike, what the fuck's going on? Isn't that your girl?" He was acting like we had to get respect. Sure enough, I hit the guy in his mouth and he went down.

Then all his friends and all our friends get into it. Before we know it, we're getting pounded against the arcade games.

Then here comes Officer Charles Martin. He grabbed

me out of the fray by the back of my collar and by the belt of my pants, literally picked me up and carried me out of there and chucked me onto the sidewalk. Jeff was still getting pounded inside, so Officer Martin did me a favor, really, even though I hated that he could literally pick me up and throw me.

Then there was the time I took Chaney with me to this place called St. Nick's, a club that was a hangout for one of these other gangs we didn't like.

I knew there was a couple of guys particularly mad at me. Something about a girl, probably. But whatever: They were always jumping my ass, and they didn't fight fair. I wanted to show them who was boss.

When they saw Chaney and me walk into that club, one of them said, "Oh, man, we been wanting to get you for a long time."

But I had a surprise for them. I pulled out a gun.

"Where the fuck did that come from?" Chaney yelled. He had no idea I had it.

Unfortunately, one of these other guys pulls out a gun, too. That was enough for us: Chaney and I look at each other, and just start running. I'm not the best runner, and Chaney's really not fast, either. Within a couple blocks, the gang members start gaining on us, so I did the only thing I could: I fired over my shoulder in their general direction.

But those crazy motherfuckers must have known I didn't want to actually shoot them, because they kept chasing us.

Chaney sees what he thinks is a police car and yells, "Cops!"

I throw the gun into the bushes. Then I realize it's just a plain old Crown Victoria, not a police cruiser at all.

"That's not even a police car!" I yell at Chaney. "You stupid ass!"

So now these guys are gaining on us and I'm scrambling, trying to find where I threw the gun.

"Found it!" I yell when my hand closes over the gun.

Chaney and I take off again and go through all these back roads and down railroad tracks, hiding in bushes, dodging and weaving. Even after we've lost them, we keep running and hiding. Finally, we get home.

Chaney's pissed, though. "What the fuck was that, man?" he says to me.

"'That'?" I said. "That was fun."

Chaney couldn't handle that much fun, so I went back to my original plan: trying to get guys from the other gangs to like me. And I figured the best way to do it was to make them laugh. You'd see these guys from other gangs sitting out in the park. I'd go up to them and start talking shit about all these other guys we knew, and before I knew it, those same guys who'd tried to kill

us a week before would be laughing. They'd say, "Damn, Mike, I hated your ass, but you know what? You're pretty funny."

It was a survival skill, being able to make people laugh. That was my only hope, because these kids would chase the shit out of us and really no one could help us.

I was still really hungry all the time, so I kept stealing food. I kept getting in trouble. I also couldn't walk away from all the fights.

And the punishments got worse and worse.

What got me locked up the first time was fighting with these other guys over a girl. I've always liked girls *not* from my neighborhood. The guys from the other neighborhood didn't like it, of course, and they often made that clear to me and clear to her.

I don't even remember the girl's name, to be honest with you, but she had an ex-boyfriend named Moony who kept fucking with her, and I did not like it. That was the one thing about me: Fuck with me, I'm not usually going to pull out any gangsta shit. But if you mess with my girlfriend, I'll kick your ass. In the streets they call guys like me "tender dick."

I guess I was fourteen, fifteen. The way it went down was this: At this club in downtown Indianapolis, I ran into Moony. My buddy Little Rickie snatched his belt off and hit one of Moony's little dudes in the forehead:

Pow! With that, everybody started fighting, and we were all kicked out of the club.

But it wasn't over. I tricked a friend into going and getting his daddy's .357, and I had this buddy who showed up with a chain and lock. We didn't need the gun: This guy hit this dude Moony with this chain so hard, man, I mean, it was crazy. That big old chain with a lock on the end of it fractured this guy's face; blood was running all through Moony's Jheri curls and down his face.

Eventually the police showed up and chased us. I ran hard. And I'll never forget, the cop was chasing me and he was bragging on his high school shit. He was, like, "I'm gonna catch you! I ran a four-four in Northwest High School! I went to all-state!"

And sure enough, when he caught me he got on top of me and slapped me all upside the head.

So it was back to juvie court for me. I wasn't the one that even hit Moony, but the parents of the guy who did said I'd masterminded it, so it escalated, and that's how I wound up in the juvenile detention center.

When we finally got there, I was sad, man. I was, like, *Damn, I can't believe I'm fucked-up, I'm in juvenile center for the first time.*

The first thing they did was use bug spray in the crack of our ass, and under our arms, and then our pri-

vate parts. (A lot of kids came in there with lice and all kinds of shit.) It should have scared me straight, but it did not.

When I got out a few weeks later, I went right back to stealing. This was the 1980s, and cocaine hit the scene big-time. A lot of the older guys had a connection out of L.A., and they'd use younger kids to help with the dealing, so they wouldn't be on the front lines.

But for me it proved all too easy to sell to undercover cops. I couldn't figure out why everyone I knew was dealing, but I was the only one who seemed to ever get caught.

"You're pretty smart," my brother John said. "You're just not smarter than the cops."

(John was really smart. He may have dabbled in some shit, but he always kept a job and he spent time with his girlfriend rather than with gang guys.)

Back then, everyone stole shit out of cars, too. Then, at some age, it got to be that once you were already in the car, why not steal the car, too? I learned early how to do it. All you needed was a screwdriver to crack the ignition.

But it didn't always go so well. I bought a stolen car once and went and picked this girl up in it. It was a brand-new Chrysler New Yorker, only with a screwdriver where the ignition key should have been.

"Oh, that's a nice car, this is," the girl said.

"It's my momma's," I said.

Honestly, though, she should have known the car was stolen, 'cause I had a towel wrapped around the steering column and the whole screwdriver thing.

I don't remember why, but the police pulled us over and, sure enough, they locked me and her up. This girl had never been in jail before, and she was crying. We both had to go to court the next morning. I saw her in the jail line, and she was just walking and crying. I called her name and she just looked at me and started crying harder and wailed.

In court, her mother cussed me out.

"Why the fuck would you get my daughter in trouble?!" she yelled. "You ain't shit! Don't ever come over to my house again!"

They charged me with joy-riding. I was back in juvenile hall and put on this thing called suspended commitment. It meant that if I got in trouble again, then I would automatically go back to Indiana Boys' School, aka kid prison.

They even tried putting me on a "scared straight" program, but it didn't work on me, because I already knew all the older guys who were in jail.

Dominic Amy had finally gotten caught, after years of running my neighborhood. He was a big dude, like

six-four, 240—he looked like Will Smith, but giant and street—and you could tell he was in charge of the jail. Because of how big he was, they were using Amy to scare kids straight; but when he got to me, he just talked normal, asking about people we knew in common. The counselors were mad I wasn't more scared; in fact, it was more like a happy reunion.

"You don't need to be in this program," one of the counselors said. "You know these guys and you already know this is where your ass is gonna end up being when you get grown."

"Ah, fuck you," I said. "Whatever."

Pretty soon, I did something to fuck my probation up, and they did indeed send me to Indiana Boys' School in Plainfield. I was there for three months.

Indiana Boys' School is where Charles Manson had been sent as a kid. There were some notorious little kids in that place when I was there, too. These little mother-fuckers made me look like a choirboy.

At first, I thought Indiana Boys' School was going to be like camp. I already knew the place: I'd visited a friend there, and it looked like he was having fun. The kids got to run around outside and play games, or so I thought. But the truth was it wasn't as fun as I thought it would be.

We were put in little dormitory buildings where they

had steel doors that locked. There was a dayroom where you'd come out of your two-man cell. The food was pretty good—biscuits and gravy and bananas—and this kind of Kool-Aid that we called Peter Soft, because we were sure it kept inmates from getting erections.

The truth was that place was worse than prison. You had to fight every day—stare down the baddest muh-fuckas. Once again I had to work hard to make friends in order to survive. And once again I got people to laugh, got the tough kids to like me.

On Sunday your family would come to see you, bring you chicken. You could sit in the cafeteria with your family, talk about how you were doing. But every other day, all day, you were just trying to survive. It was like a horror movie, because you'd think you got everything under control and then some new thing would jump out and scare the shit out of you. I couldn't wait to get out.

When I did, we went back to moving all over the city. As soon as my mother painted a new place, chased the roaches away, and got it comfortable, we'd get evicted and back to grandmother's house we'd go.

Being at our grandmother's was fun for us kids. We always had music, and cousins to play with, and good food on the table: It was like one big sleepover party at times, especially when my aunt Anita would sing—and she could really sing. But when I look back now, I

can see that—while it was a lot of fun for us there—for our grandmother it must have been so hard, with that house filled with loud, crazy kids. So many mouths to feed, and as ever I didn't help our case. My grandmother would make homemade candy and I would always eat it all—she never knew what happened to it. You know how bad I was? Not only would I not confess that I'd eaten the candy, I'd help her look for it. Eventually I got caught in the act. I got whupped for that, you better believe that.

Finally, with my grandmother at her wits' end, my mom moved us into a new place, a high-rise building, with a great view . . . of all the crackheads and pimps. Ironically enough, our hitting bottom meant living high above the city.

6

THE TV SHOW ON CENTRAL

We wound up in the high-rise Sherwood Tower, Section 8, and my mom, who still had her pride, refused to call them projects.

For a while, my mom, my brothers, my sister, and I all lived in an efficiency apartment together, then we moved to the very top floor—the penthouse! But it sure didn't look like the apartments we saw on TV. This was no *Jeffersons* penthouse.

In our not-so-deluxe apartment in the sky, we watched TV a lot. We especially loved seeing comedians on TV. We stayed up late to watch *Saturday Night Live* and whatever specials came on the networks. All day, Chaney and I would repeat lines to each other like "Buckwheat has just been shot! I repeat: Buckwheat has just been shot!"

I never thought I could do comedy for a living. Chaney and I used to watch comedy shows, and my family and friends sometimes used to say, "Man, Mike, when you get older, you should do that shit. You're way funnier than some of them guys."

"Yeah," I'd say, "I should."

But I never imagined I could be one of those guys. It was almost, like, "You should be Superman when you grow up" and I was, like, "Yeah, for sure I should. I'll get right on that."

Eddie Murphy's 1987 special *Raw* was the most incredible shit. I'll never forget that. Murph was the man back then. (He still is.) And Richard Pryor was a god. We also watched Benny Hill, all that shit. If there were jokes, we were there.

One good thing about watching so much TV was that after a while it gets hard to see the difference between TV and life. Just how we used to make children's TV characters into real-life ones, once again I started to see our whole life as like a TV show. This was a little bit before *Law & Order*, but the TV show we lived in was kind of like *Law & Order*, only we were on the side of the bad guys. If we saw some Jerry Orbach–looking motherfucker showing up in our neighborhood, we knew it wasn't going to end well.

When there was nothing on our little apartment TV to

watch, I'd go to watch the best show in town, the one on Central Avenue, which was like Main Street for crime. A guy named Frank ran Central Avenue and, man, he was a hustler. I used to watch him go grab the stash, tell cars to pull over, run up to them, sling the weed. Cars were lined up; they were selling weed like it was legal back then. Some days there'd be a shoot-out, too—*pow, pow, pow, pow, pow*. The cops pretty much kept away.

Those Central Avenue characters were so great, though—I found them so entertaining. When you're in a neighborhood with different types of people like that, it's easy for you to grab a character and run with it. I'd do impressions of them, pick up how they talked and how they moved, then try it out on Chaney or whoever else would watch.

I remember one guy, an older hustler called Jitterbug. Jitterbug was known as the Godfather, the kingpin of the neighborhood. He even put the word GODFATHER in giant letters on his belt buckle. (I think every kid in the neighborhood wanted to have a belt buckle like that someday.)

Then there were the prostitutes. They loved me. They pinched my cheeks and gave me dollars for candy, telling me I was cute and funny.

"You're going to be my daddy when you grow up!" they'd say to me. "I'll bring you some money!"

I thought that sounded pretty good, but I knew it would be years before I could be a real pimp. No one was going to be intimidated by a scrawny kid. And I wanted to make money *now*.

And so the ladies helped me out. Sometimes they'd take guys into the basement and tell me so I could go rob their cars. So while the guys were going up in the elevators to the ladies' apartments, we were going down in the elevators to steal the johns' car radios and wallets.

The best part was: These johns wouldn't report it, because then they'd have to explain what they were doing parked in that neighborhood for an hour in the middle of the day. There wasn't exactly a scenic overlook on that block.

For real, though, I think it was watching all the people in that neighborhood that made me a performer. It was the best show in town. My heroes in my neighborhood were people who had faults, but they were great people. I mean, check out this motley cast of characters:

One guy who dressed like a real pimp who lived nearby was named Leneral—spelled *General* but with an *L*. He must have changed his pimp clothes fifty times a day. What kind of walk-in closet must he have had? Do you know how much space fur coats take up? Leneral had, by my count, five hundred of them.

Then there was this drug kingpin dude who was like the mayor of the building: He knew everything that was going on. One day, we saw him fighting out front with this pimp from the building.

"Quick," our mom said, "let's get inside, but slowly, so we don't attract their attention."

We had made it through the front door when we saw the dealer reaching for something in his pants.

"Oh shit!" Chaney yelled. He'd made it to the elevator and was pushing the button like *Go, go, go.* My mother and my little brother Nathan and I were behind him, so I pushed them down and we lay there while we heard *blam, blam, blam.*

Once the gunfire stopped, we stayed low and made it to the staircase and started running up the stairs. We caught up with Chaney, who was running down to make sure we were okay.

I was worried about the drug kingpin, and I was glad to hear he survived. The other guy did die, though. We heard later that he ran but they found him half a block away. He'd collapsed and bled to death.

Then there was a guy in our neighborhood named Duke who used to be a basketball star at Arsenal Technical High School. He was all-American, but when his mother died he lost his mind. He ended up on meds and used to just wander around the neighborhood,

waiting on his disability check. Everybody knew him, and he still got some respect because he'd been a sports star.

"Duke!" I'd shout when I saw him.

"What's up, nephew?" he'd say to me.

"What you gonna get when you get your money?"

"Oh, nephew. What I gonna get with my check? I'm gonna get a brand-new Park Avenue. Crushed-velvet seats. It's gonna smell like vanilla incense. You gonna ask for a ride and you know what I'm gonna say?"

"No?" I guessed.

"That's right. No."

I loved Duke.

Then he'd say: "You think you can get me a coffee, Mike?" And I'd go get him a coffee.

There was a wino in our neighborhood named Scotty, and he used to get drunk, but he was always happy. He used to always call me superstar: "Superstar! There's little Superstar." Even on his bad days, when he saw me he'd be all "Who the superstar?"

There was another character, Smitty, who you'd always see walking around. Wake up in the morning: There he is. Go to bed at night: There he is. Walking, walking, walking. Smitty used to walk real fast. He walked the whole city.

You'd say, "Smitty! Hey, Smitty!"

He'd shout back, "Hey! You know me? Where you know me from?"

"Yeah!" I'd shout. "You're from the East Side."

He'd wave, but he'd keep walking. He'd walk all over the city. Goddamn, that motherfucker walked everywhere.

"Why you walk so much, Smitty?" I'd ask.

"Because that's what Jesus did," he'd say. And he'd keep walking.

My favorite character of all was Shu-Pu, a local thief and drug addict. He broke into everyone's houses, stole shit, sold it for drug money, got high, got caught, got out, did it again. Over and over, week after week, year after year. Still, he always just seemed like a small-time guy—not scary. No one thought much about him; he was a nuisance, mostly.

Then one day there was a big fire in the neighborhood.

"There are kids in there!" a woman screamed to the big crowd gathered in front of the house.

Another woman, the kids' mother, had gotten out of the house with some of the kids, but there were still three in the house. The mother was hysterical, but her friends were keeping her from running in after the other kids.

Finally, the fire truck rolls up. They get the hose out,

start spraying the house off and pulling pieces of the roof off, tearing it up, getting the water in.

"There are three kids in there!" everyone's screaming at the firemen. "Why aren't you going in?"

"Fire's still too strong," one said.

"That's your fucking job!" someone screamed.

"You go in that fucking house right now and get those kids or I'll shoot you in the head!" yelled another.

"If y'all don't go in the house, we going to kill your ass anyway!" said another.

Those firemen were stuck—between a house in flames that would kill them if they ran in and a mob that was about to kill them if they didn't. They were going to die one way or the other, you feel me? You could tell they were pretty sure the kids in there were dead, but they must have thought they should run in for show. Meanwhile, they kept hosing the house off, trying to get the fire under control, and getting screamed at while they did it. And all the time, the mother is wailing.

Along comes Shu-Pu.

"What's going on?" he says.

Someone fills him in.

Shu-Pu just starts barging through the crowd, *boom*, knocks everybody down in his way. He just pulls his shirt up over his mouth to block the smoke and runs into the building.

"Well, he dead now," one lady says.

But a couple minutes go by, and then, out of the smoke, here comes Shu-Pu! He's carrying all three kids on his back. He rolls those kids off his back onto the sidewalk. They're covered in soot, coughing, but they're alive.

Their mother's hugging them. The whole neighborhood is screaming Shu-Pu's name: "Shu-Pu! Shu-Pu! Shu-Pu!" They're patting Shu-Pu on the back, calling him a hero.

"That's a real man!" everyone's yelling at the firemen. "Not like you!"

Everyone's about to get Shu-Pu the key to the city, hand him money, get him drunk. But then he says, "I heard more people in there!" He starts running back to the house.

People tried to grab him, but he ran into the house anyway.

"Well, he's *really* dead now," the same lady says.

Shu-Pu came out a few minutes later, carrying some stuff in his arms. Not people—electronics.

People are complicated. He's a great man, and he saved those kids, but he's still a thief, too. Back then I knew plenty about being two things at once: I was a nice kid, a sweet kid, someone everyone liked. But I was also real bad.

And as I got older, I was getting worse.

7

CRIME DOESN'T PAY—
UNLESS IT'S PAYING YOU

"I just saw you on the TV news," my mom said one day when I got home.

"Uh, for what?" I asked. I wasn't hardly going to school anymore. I was probably about sixteen. By then I was mostly hanging out on the streets. So there were a few things I could have been on the TV news for, but none of them were good. Still, I held out some hope that maybe I'd won the lottery or something.

It turns out that the news had done a segment on the city wanting to clean up our part of town, and illustrating the story was video of me standing on a corner. That was me: star of juvenile delinquency B-roll.

Chaney and I had left Stephen Decatur early in high

school. I don't think they were too sad to see us go. After Decatur, we moved to a school closer to home, Arsenal Technical High School. We were kind of relieved to be out of Stephen Decatur, but we missed the good food. And it was rough at Tech.

Chaney and I both played on the Tech basketball team. One day, we got to practice and the coach started yelling at Chaney. Chaney was such a good kid, he was just completely confused.

"I'm so disappointed in you," the coach said to Chaney.

Chaney was just looking at him, trying to think of what he did.

"Man, I just don't know what the hell to do with you," the coach said.

"Sir," Chaney said, "what did I do?"

"You flunked off the team," the coach said.

"Oh, no, I don't think that's right," Chaney said. "I'm on the honor roll. If there's an Epps flunking off the team, it's probably Mike."

Guilty as charged. I got straight Fs. But I did not want to get thrown off the basketball team, so I tried to get that fixed—not by studying, mind you, but by getting one of my girlfriends (I always had girlfriends) who worked in the office to change my Fs to Ds. A little Wite-Out and typing, and *wham*, back on the team!

Or so I thought. Unfortunately, my girlfriend-accomplice worked her magic with the individual grades but she didn't change the grade point average. So while I had a lot of Ds, I still had, suspiciously, something close to a 0.0 average.

I was so bad at school, and the rest of it, that I got put in the special-ed class. When I was little, I'd been the goofy one, the laid-back kid in the back who makes everyone laugh, but now it didn't seem as cute to everyone how naughty I was. It seemed like it was starting to be a really big problem.

Man, that special-ed class was so boring and frustrating. It was like being in day care. Do you know how embarrassing it was not getting to change classes like my friends? The bell would ring and we'd hear movement in the hallways, and I'd start to get up.

"Michael, why are you getting up?" the teacher would say.

"The bell rang," I'd say, pointing at it.

"That's not your bell, Michael," she would say.

Not my bell became a metaphor for everything that wasn't going right for me. *School,* I thought, *isn't my bell. All this bullshit around me isn't my bell. When is my bell gonna ring?*

I got madder and madder, and more and more restless.

Then one day I'm in sophomore year. Chaney's a

freshman and it's lunchtime. I walk up to him, grab his coat, and say, "Chane, come on, come on."

Chaney being Chaney says, "Oh, okay."

I take him over to where I've been sitting and we sit down. I'm waiting. There's one guy at the lunch table who had it coming to him—I forget why, but the second this guy opens his mouth, I punch him in the face. With that, the whole table jumped up, and now we're in a food fight.

Chaney looked sad to be involved, to be honest. He loves food. And like I've said, oftentimes lunch at school was the only time we were able to eat that day. The last thing he wanted was to be throwing around perfectly good french fries.

Next thing you know, we're off to the dean's office, where we get expelled.

Chaney was a bright kid, though, and he piped up and said to the dean, "Well, sir, actually we don't really live in your district. We've been lying this whole time. We're supposed to go to Emmerich Manual High School. So maybe, instead of expelling us, you could just transfer us over there?"

The dean looked at us and probably realized there was less paperwork in a transfer, so off we went to Emmerich Manual High School. Well, Chaney went; I basically

dropped out. Besides, I figured I was learning a lot more useful shit from the streets. Our neighborhood was full of people who were making a lot of money, and I wanted to be like them.

My dad saw what was happening—that I was heading toward becoming a regular street thug—so he signed me up for the Jobs Corps in Detroit, Michigan. He thought it would help me to get out of town and away from my gang friends.

"Your ass gonna get a trade, man," he said as he put me on the Detroit-bound bus. "I don't care what trade you pick, just pick one. Learn something."

The trade school always accepted dropouts, and it was a place where you could go become an electrician, a carpenter, a plumber. I signed up for something—I can't even remember what. I did want to make my father proud, and becoming a tradesman seemed as good a way as any I could come up with. And I knew if I stayed in Naptown, nothing good was likely to happen.

When I got to Michigan, I was so excited. Detroit was beautiful to me. I was seventeen and it was almost the first time I'd ever been out of town. Life was looking good. I liked the place, and I had an older girlfriend from back home who had a car. Nicky was twenty-one and I was in love with her; she used to drive her little

red Stanza from Indianapolis to Detroit, pick me up, hang out there, or bring me back to Indianapolis for visits.

The only problem Nicky and I had was the age thing. When we were out in public she used to tell people I was her little brother. I'd be looking at her like *Little brother? Tell 'em what we did last night. I sure as hell hope you don't do that with your little brother.*

Man, I would have so many kids right now with Nicky if it weren't for Queen Williams, her mother. She would *not* let her have a kid by me. If it took every condom in America and a million abortions, Queen Williams would keep her daughter from getting linked with me for the rest of her life.

Finally, Nicky broke up with me. I had it coming, I'm sure. I just wasn't equipped to be a boyfriend at the time, you know? But it broke my heart.

Then Michigan Job Corps broke up with me, too. My career doing a trade was sunk by one main problem: I found out that every trade required me to learn math. I couldn't be an electrician because you had to know math. Couldn't be a plumber 'cause you had to know math. Couldn't be a carpenter 'cause you *really* had to know math. You can't build a house if you don't know measurements. And I couldn't tell a meter from a yard from a whatever the fuck. There was just no way.

Finally I was, like, *Okay, I can't get a trade,* so I went back home after about six months. My parents were not happy to see me back, especially with no skills—me, a high school dropout and basically unemployable.

All I'd picked up from Detroit was a sense of style. And I remember coming back home, I seen all these guys from Detroit, they were wearing finger waves and carrying briefcases. So I got finger waves in my hair and started carrying a briefcase.

My mother took one look at me and this new getup and she said, "Nah-uh. You ain't goin' back up there."

That was like some pimp shit, you know. I thought I was a pimp because I looked the part, never mind I had no ladies and no money. But I did have a briefcase. There was nothing *in* the briefcase, but I still carried it everywhere.

Of course my dad was real mad that I came home without knowing how to do anything that could get me a job. I remember him cussing me, saying, "Man, you's a fucked-up dude for that shit. You know I took all my time trying to help you, get yourself right!"

So eventually I found a job unpacking boxes, stocking shelves, and cleaning up at a 7-Eleven where my uncle Eric was the manager. It was tiring work, but I did my best in my stupid uniform. I didn't love it, but at least my dad was off my back. For all that hard work all I made

was $116 a week. This was no kind of long-term plan, that was for sure.

And it wasn't winning me any friends. One night I'll never forget, a guy I grew up around showed up in the store.

His mother was a madam who ran this big house, famous for its gambling and prostitution. She was no joke. My friend's whole childhood, every time we were over there, a million times a day she would holler, "Quick, get that motherfucking door shut. You all get that goddamn door."

Her whole house was a hustle. She had different beds in the basement and she would get different checks from the guys she let sleep there every month. She would get their checks and then just give 'em their money that they needed, keeping the rest.

My friend's father was a hustler, too—numbers runner.

That family just stuck out like a sore thumb in their neighborhood. My friend was bad as hell, and me and him used to fight all the time. He was also the first truly successful kid drug dealer that I ever knew. He was sixteen.

Anyway, one night I'm working at 7-Eleven and this old friend of mine and some of our other buddies come in. I was sacking groceries, and they started laughing at me in my 7-Eleven uniform.

"What the fuck you all laughing at?" I said.

They had jewelry on, new sneakers.

I was, like, "Damn, where the fuck you all get the money at?"

"Yeah, we got money right now," my old friend said, and he pointed to the parking lot where he'd parked his brand-new car.

I'm, like, *Damn, this dude's making money, man. Why the fuck am I working at 7-Eleven?*

It was hard to sack groceries and watch them little dudes come in there, brand-new Jordans on, driving a new Bonneville. I felt like I was made for something better, and I knew I sure as hell wasn't going to get there at 7-Eleven. I decided to give crime a real shot.

It's like they say, "Crime doesn't pay—unless it's paying you." So I took one of those little 7-Eleven paychecks and I went and bought an eight ball so that I could flip it.

An eight ball back then cost $150 to $200. That's three and a half grams from which you could make $300. And then you take the $300 and you buy a quarter ounce. A quarter ounce, you could flip that and make a half ounce. A half ounce you flip that, turn it into an ounce. An ounce could turn it into two. Two could turn it into four. Four, turn it into more. Then you got nine ounces as a quarter kilo. Nine ounces turn into eighteen ounces.

Eighteen ounces turn into thirty-six ounces, which is a kilo of cocaine.

Huh, I guess I could do some math after all. I'd never been able to even really add well before, but now all those equations started to make sense. Because the solution to every math problem now was that I had more money in my pocket.

I was good at hustling drugs, just like I'd been good at selling candy. I could talk people into getting more than they wanted. And I had a good work ethic. I showed up on time. I put in the hours. I made the connections.

I also wasn't afraid of anything. I'd go anywhere if I thought it would result in a sale. For instance, they had some of the most notorious projects in Indianapolis on Twenty-Fourth and New Jersey. So many people had died in those buildings, they felt haunted. I mean, this corner was so tough, the devil wouldn't stand on it, you feel me? There were prostitutes, there was drug dealing, there was killing. I went down there, you know, to earn my rank on this corner, and I walked on there like I owned it. I learned a lot, like that you shouldn't hide cocaine in your underwear. You should hide the bags in your mouth, so you can swallow them if the cops show up. I learned that even if you're not using cocaine, it can

show up in your system if you're handling it without wearing gloves and a mask.

Everyone thought about killing me, I'm sure, but I was a nice guy and I was funny and young, still just about seventeen. I knew I'd make motherfuckers laugh. I knew how to manipulate people. This was a corner they didn't let nobody come on, not that neighborhood; that was *their* neighborhood. But they let me. I'd been a real funny kid and now I was a real funny guy. I was popular. And I was making so much cash.

For a while I had real good luck, too. One time, a friend and I went and bought half a key from these guys in this rough part of town. We were driving around with a half a key and we got pulled over by the cops. They knew where we'd been and what we must have in that car. We knew this was going to be bad for us.

"I'll take this," my friend said to me. "You get out and run."

I was going to bolt, leave my friend to sort it all out there. But I froze up, couldn't move.

"Sir, please put your license out the window," the cop said as he came up to the driver's side.

My friend put his license out the window.

The guy turned his flashlight on.

"How many people are in the vehicle?" the cop said.

"It's a two-seater, Officer," my guy said.

"Well," he said, "get your black ass home now."

There was still a huge bag of coke sitting on my guy's lap.

We thought surely the cop would have seen it, but apparently not.

We thought it was a trick. We looked at each other confused. But, nope, he was just letting us go.

We rolled out and went home, shell-shocked.

"Well, we made it through that song, yes!" my friend said.

We laughed the whole way home.

Things were going okay for a while. I had money for the first time in my life. But the thing is, when you're dealing, you have to do a lot of rough shit to keep control of your territory, and to make sure no one takes advantage of you. As I got older, from necessity I started to do some seriously bad shit. And I knew every guy I came down on had a whole gang full of guys who were then going to be after me.

I never quite fit in, because the one thing you can't have when you're a drug dealer is a heart. Even though I was bad in a lot of ways, I was too sensitive to want to hurt people. I wasn't cut out for that life, either by skills or personality. And so even as my friends went on to careers in drug dealing, mugging, and armed robbery, I

was a failure. Once when I got in trouble, a presentence investigator (that's the guy who talks to you and then tells the judge what kind of guy you are) said to me, "You have a calling. You don't belong in the Department of Corrections."

I'll never forget that. He was right, but I wasn't ready to listen yet.

While my friends got better and better at crime, robbing shit out of cars was about the limit of my skill as a crook. It was like if you can't quite do long division and then suddenly everyone around you is writing complex shit on the chalkboard. I was still trying to figure out the best way to quietly steal a hubcap, and everyone on my block is staging *Ocean's Eleven*–type heists. They'd try to get me to help them. I'd do my best. I really would. But I always seemed to fuck it up.

This one time my friend and I broke into a big house and got all the stuff ready to go. The people whose house it was had this big-ass Doberman pinscher. While we were getting all the stuff laid out to take, we were petting him and everything. We couldn't believe our luck. Then, when it was time for us to go, the dog got mad. It's like he suddenly remembered he was a vicious guard dog. Or maybe he just had grown to like us and didn't want the petting party to end. Well, he wouldn't let us out of the house. So my buddy and I did the only thing

we could think to do: We called the police on ourselves. That call went about like you might imagine:

"Nine-one-one. What's your emergency?"

"Guess what?" said my friend.

"What?" the dispatcher said.

"We broke into this house and this dog won't let us go," my friend said. "We'd rather go to jail then get ate up by a dog."

And so, for the next few minutes, we sat there surrounded by silver and jewelry, petting the giant dog, listening for the sound of sirens. The cops may have caught us that night, but at least we didn't get eaten.

Out on the streets, cocaine was really taking hold of Naptown, and things started getting more violent. Nowadays the kids, they go do shit off of lean (which my editor is making me explain to you is codeine-laced cough syrup, mixed with soda and Jolly Ranchers) or Percocets or heroin. They damn near gotta be high to go do some crazy shit. That's where they get their courage at. Back in the day, we kids didn't have any of that. Where we got our courage was from drinking Wild Irish Rose red wine. Bum wine. And from being desperate.

One night, Fatso and Ramon and some other guys and I are just all out chilling in an alley right there on Thirty-Third, right on Dirty-Third, drinking Wild Irish Rose.

"Man, let's go hit this lick," Ramon says.

I'm, like, "What you talking about, a lick? What you mean, go get a lick?"

He says, "You want to get this money?"

I did want money.

"Come on," Ramon said. "Let's go."

And off we go, Ramon and I. We're joking and drunk until we pull up in the parking lot of a pizza place called Noble Roman's. We get out of the car and Ramon pulls out latex gloves.

Oh shit, I thought. Latex gloves is professional. Latex gloves is bad news.

Ramon hands me a pair of latex gloves and a gun, and I'm, like, "Damn!"

"Go in first," Ramon says.

I pulled my shirt up over my face. That's how amateur and shit I was.

"Shit!" I say. "Where you gonna be at when I walk in this motherfucking door?"

"I'm gonna be right behind you," he says.

I'm, like, "Shit, man. I ain't never did this. You go."

By this point I'm scared, but I don't know what else to do.

Then I freeze.

I'm so unprofessional at robbing, I go in the door and don't say nothing. I just start waving the gun.

The cash register girl's just ducking and looking at me, more confused than scared.

Then Ramon came in the door, all "Grrr! This is what you do!" He starts moving fast, ordering everyone around, looking like a whole different person. He looked really fucking scary, even to me—he didn't look like my friend anymore, he was just a *robber*. It was so crazy, when we was robbing the place, it looked like the nigga wanted to rob *me*, like he wanted to say, "You got some motherfucking money in your pocket, too?"

We got $85. And a pizza, too. We're leaving and we're going to get away. But then something happened—to this day I don't know what. For some reason Ramon goes and hits the girl behind the counter in the head with his gun.

"Why'd you hit the lady?" I yelled. "You didn't have to hit the lady!"

I started crying.

"You're gonna ask me that here?" Ramon yelled. "Get it together!"

I followed Ramon out to the car, crying the whole way.

It was quiet in the car on the way back to Dirty-Third. "I'm done," I said. "You gotta be a vicious motherfucker to do this. This ain't my sport. My mother raised me better than that."

Yes, I caught feelings at the robbery.

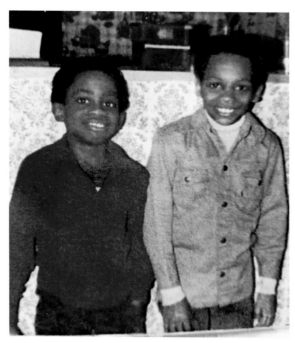

Me with my
brother Chaney
at our dad's
house, when
I was nine and
he was eight.

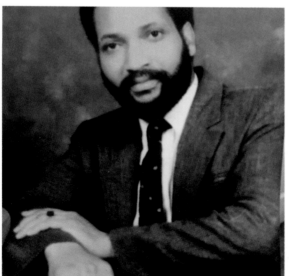

Our father,
Tommie Epps,
circa 1985.

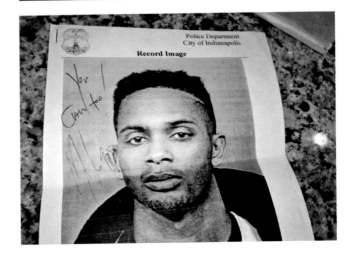

Yolanda took this during my street hustling days, circa 1991.

One of my mug shots from the early 1990s.

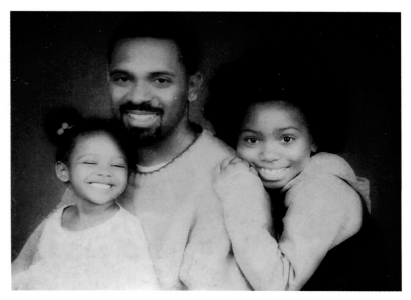

Me and my daughters Bria and Makayla.

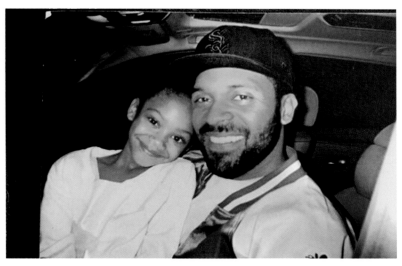

Me with my daughter Makayla, when she was about five or six.

Playing the piano backstage in a comedy club in the early 2000s.

Doing stand-up in Detroit, at Joe Cole's House of Comedy, 2008.

Me with Richard Pryor, 2010.

Me with my dad and
one of the newest
members of the pack,
Jalan, 2012.

Surrounded by cash in Napa, where everyone posts their name on the wall, 2012.

Live onstage in Nashville, 2015.

Me with Rickey Smiley, 2015.

Me with Mike Tyson, on the set of *Next Day Air*, 2009.

Me with my daughter Bria, backstage, circa 2015.

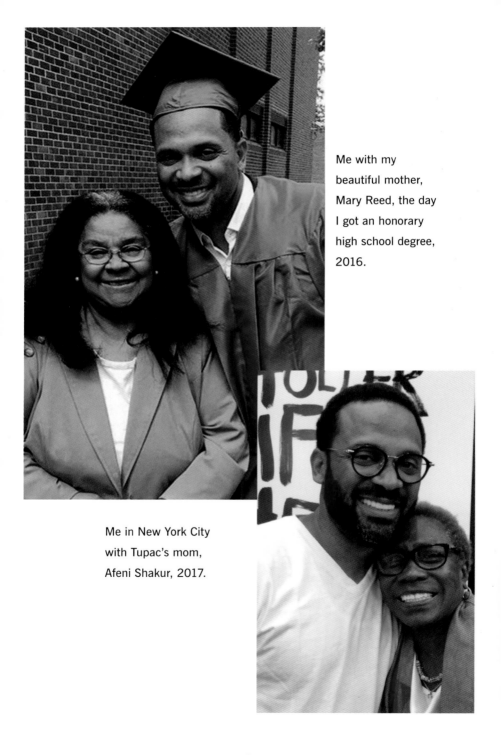

Me with my beautiful mother, Mary Reed, the day I got an honorary high school degree, 2016.

Me in New York City with Tupac's mom, Afeni Shakur, 2017.

Still, I didn't know how to make a living honestly. So I just kept fucking up again and again.

Around this time, my buddy Ray Bob came around one day and asked if I wanted to do a robbery with him out in Haughville. Haughville was a poor, almost all-black Indianapolis neighborhood west of downtown. Check out the stats sometime: Back in the '90s, Haughville had thirty homicides a year, which made it one of the worst crime zones in the whole country. One year was so bad, one in every 2.5 people was the victim of a violent crime. And I knew a lot of the guys who got the place that title.

Me and my buddy Ray Bob, we riding, and we just circling the projects, because we trying to catch one of the dealers out there. We riding, and we see this one dealer sitting on the ground, counting his money. We went and parked the car by the railroads, put masks on, and ran up, snuck up on him with a gun.

While we were robbing him, I kept saying, "Push him over there, Ray Bob!" "Hand me that rope, Ray Bob!"

I might as well have been, like, "Give me the rope, Ray Bob who lives in Mapleton on Ruckle and who is five feet eleven inches and who will be on Central Avenue after four p.m. on Friday if anyone needs to drive by and shoot his ass!"

Ray Bob hissed at me through his mask. "If you call

my name one more motherfucking time while we're robbing this guy, I'm gonna fuck you up, too."

When we got back in the truck, Ray Bob ripped his mask off. Right away, he started yelling at me: "You said my name five motherfucking times!"

What can I say? I was an unsuccessful thug.

I was at my grandmother's house one day at the height of my dealing, sitting at the kitchen table, and in front of me was a big bag of cocaine. I got up for a second and when I came back, it was gone. There was only one person who could have taken it: a female relative of mine who was staying at the house and who was addicted to crack. After that, I wouldn't give her any dope, I was so mad at her, and when I wouldn't give her any drugs, she got her revenge: She called the cops' drug tip line and ratted me out.

But I only found that out later. I'd heard from my buddies that the heat was on, but a few days after I'd cut my relative off, I needed to check one of my stashes, which was by my grandmother's garage. Well, just my luck: A rookie cop, first week on the job, was sitting across the street, hot on the tip, just waiting in case I was dumb enough to go back to get the drugs.

I was dumb enough. I got to the garage, pulled out the dope, and then I hear behind me "Freeze!"

The cop was so proud to have a bust like that on his

first week, he seemed surprised by his luck when he put the cuffs on. So happy, like I'd made his year. You're welcome, rookie cop.

You know, at the time, I was pretty upset at the relative who turned me in. That seemed like not how family should be. But today I'm glad she called the police.

I think she saved my life.

8

JAIL, PRISON, AND WORK RELEASE

The Marion County Jail—man, what a crazy place. It was a really old jail, though they'd just renovated it and added a new wing. Even so, the place was so crowded, I stayed in my cell for the first three weeks with the same clothes on. My Chicago Bulls starter jacket should have been burned by the end, it smelled so bad. We had a $45 commissary that you could order from, so eventually I got these small boxes of Tide detergent that let me stay clean until they gave me a prison uniform.

There were two tiers to the jail, upstairs and downstairs. The downstairs tier had two bunks in a cell. When I first arrived I had to share a cell with a guy on

the downstairs tier. After about three, four months I got the penthouse cell upstairs, and that's the one I made my own.

When you're in jail, everybody's making shit, so you learn a bunch of tricks to make your time more bearable. I braided three towels together to make a carpet; I took some toilet paper and some soap and made it real sudsy, then let it dry (once you lit it, it gave off a nice aroma, like a scented candle); I put some pink medical cards on my lights so it made the room dimmer. We also would tear pictures out of this black magazine, *Right On!*, and use toothpaste to paste them onto the concrete wall.

One of my guys in there ended up getting sentenced to the death penalty. They said he killed some white people, while robbing them or something. He had been in the county jail for, like, two and a half years, and when they were shipping him off to death row at Pendleton Correctional Facility, he gave me all his stuff. There were big bags of popcorn and chips, all this great stuff. People couldn't believe I had all this shit. If anyone wanted anything, they had to come to me. I was rich, in jail terms. I even ended up with the honor of running the poker game. I was living large.

We also watched a ton of TV. *Video Soul* on BET with Donnie Simpson; *Yo! MTV Raps*; *Comicview*; *Showtime*

at the Apollo. Sometimes Steve Harvey would be on there and we'd get excited to see him.

"I'm gonna be on that show one day," I said. "Everyone thinks I'm real funny."

"Like hell you are," my guys would say.

All my dreams of comedy felt very far away, though. In fact, being in jail felt more like being back on Central Avenue watching the hustlers, only now the characters were doing other stuff, like finding religion, or getting their GEDs, or fighting with one another. For me, it was more characters to study.

My favorite bit players were what we called the jailhouse lawyers—inmates who spent all their time in the library poring over lawbooks and case files. These guys had so many books and so many theories and they had a million ways they were going to help you get out of prison.

"You need to go get a mistrial declared!" they'd say, or some shit. We didn't think much of them. They were always trying to help everybody else get out, but they couldn't do shit for themselves.

"You so smart, motherfucker," I'd say, "why you in here and not out free?"

I also loved the Nation of Islam guys. I tried to be Muslim once. I really did. But I couldn't handle Ramadan. I Rama-didn't. I was too damn hungry.

"You are strong!" I was told once while we prayed, and the fact was, I did have a lot more energy than everyone else.

"Must be the spirit," I said, knowing full well that it was actually the peanut butter-and-jelly I'd snuck when no one was looking.

Three days in, I got caught with a ham sandwich.

"Sorry, I can't do it," I said. "I get what you're trying to do here and I respect it. I just can't give up bacon."

THEN I GOT sentenced and had to go from the jail to the prison to serve my term. Those two words, *jail* and *prison*, get used interchangeably, but not by people who've been in both. Jail is where you go when you get arrested. If you did something small, you might just stay there for a few months or whatever, or even if you did something really bad you might be there until you have your trial or before you get sentenced.

Jail I was basically okay with. Prison was a whole different ball game. The prison bus came every Saturday. And one day I was on the list for transfer. I remember them chaining me up, putting me on the bus, taking me to the RDC—Reception Diagnostic Center. Sounds kind of nice, right? Like a health clinic or some shit.

Well, it's not. RDC is where they send you to find out

if you've got AIDS and to check your mental health, all that shit. And once you've had your tests, they put you in thirty days of what is basically solitary confinement. That's the roughest part of your time. Fuck, it's probably the roughest time in your *life*. If you weren't crazy going in, you're sure as shit crazy coming out.

To make it legal, they let you out for an hour a day, and that's it. The other twenty-three hours, you're just in this little room alone, with nothing to do except think.

My whole first fucking week I just cried. All day, every day. I was so desperate for anyone to talk to, to see another face or to hear another voice. I dreamed about fresh air, grass, flowers, trees, clouds. I'll never forget I used to get down on the ground and put my face at the bottom of the door so I could see a little down the hallway. It made me feel like I wasn't in jail. It was, like, *I'm in the hallway!* But I wasn't. Just my eyes and my nose and my lips could get close to it a little bit. But that's how desperate I was for that whole month. If I could smell the hallway, it was like freedom to me.

Smelling the fucking hallway.

The results of my RDC tests were mixed: I didn't have any bad diseases, but I wasn't that smart, either, so they sent me to the worst gladiator school of the prisons I could have ended up at: Westville Correctional Facility, up by Chicago. If your health is bad, they put you in

a place where there's a medical center. If you're really smart, they send you to some cushy, nice place. But the tests said I wasn't special, so I went to the worst place of all.

Another bus ride, this one as loud as fuck. Everybody was talking shit at the top of their lungs, cursing, telling stories, right until we got in front of that prison—then dead silence. We were trying to take it all in, I think, to memorize every blade of grass, every inch of sky, until we vanished into that building for however many years we had to do.

I wished the sun was out, so I could see it one more time before I went in, but that morning was rainy. Every prison bus I ever took was in the rain. And the last song I remember on the prison bus radio was "Save the Best for Last" by Vanessa Williams.

Westville was definitely not the best anything. It used to be an insane asylum and I believed people when they said it was haunted. I remember one time laying in my cell and seeing something weird zip past. It gave me the creeps, I'll tell you what.

That place was so tough that I quickly realized that I really wasn't the street guy I thought I was. I was surrounded by real criminals, guys in gangs like the Black Gangster Disciples, the Vice Lords, the Black Kings. And I'm, like, *Man, I'm a nice kid compared to these guys.*

You'd think the experience would have scared me straight, but whenever I got out, as much as I wanted to do something else, I couldn't stay away from drugs for long. As a result, for a few years there I was regularly in and out of both jail and prison.

One time, a friend and I were partying in Bloomington. On our way back, we got pulled over. My guy was out on bond on a case, so as we're getting pulled over, he's, like, "Please, Mike, take this pistol case for me. Say it's your gun."

So the cop comes up to the driver's side and takes our licenses and asks if we have anything in the car and I say, "Yeah, it's my gun."

It wasn't registered, obviously, so I took the rap on that. My guy bailed me out and everything, but when it went to court, the judge was talking crazy. He didn't care about our fancy lawyers. He wanted me to do some real time. The good news was that I got put in the jail down there where I'd gotten picked up, which was near a college. It was a white jail, full of white guys with DUIs, and it was immaculate. It had carpet! That's the only time I ever got locked up anywhere with carpet. I spent a year there, and it was the nicest time I ever did. I learned so much about white music, like AC/DC and Led Zeppelin. I got to like it.

A year later, a similar thing happened. The police

pulled right up into the same friend's yard, searched our car, and found my beautiful Colt .45. They thought it was his and we didn't say anything, so that time he got charged with having the illegal gun.

"I guess we even now," he said as they took him away.

I'd get out of jail and then I'd get caught and I'd go back in. Over and over.

The last time, a judge named Webster Brewer sentenced me to do my backup time, because I violated my probation. I got sentenced to ten months back at the good old Marion County Jail. This was in the early 1990s, and I was in my early twenties.

One condition of them finally letting me go was that I went to a work-release place for thirty days called Riverside Residential Center, on Pennsylvania Street in the middle of Naptown. While you were there you had to go find a job—but there was nothing out there. I tried places like Hardee's, White Castle—but no one wanted me.

The truth is I didn't want them, either. I didn't want to work fast food, period. I needed money, though. So I did the only job I knew how to do: I got a pager and a quarter ounce of cocaine powder. But it just wasn't selling. It just wasn't there for me anymore. I'd lost all my hustle.

Still, I kept trying. I lied to the work-release center and

said I worked at this place called LD's Garage. (LD was just a guy that was a mechanic that used to work on my cars.) The guy who ran the center, Lloyd Bridges, liked me, so even though he could have sent me back to prison a million times, he never did. Every time I showed up, I told them I'd been at work—a cash job—and I would hand over to them $120 a week. The way it worked there, you'd bring them your paycheck and they'd help you manage and save it so you could get back on your feet, learn about having a real job and paying your bills on time and all that. I was learning, though, that I didn't know how to make any money that wasn't drug money.

There was a bright spot to that period of time: my girlfriend Yolanda, aka Pookie. Yolanda was standing on the corner with her friends, and when I saw her, I did a U-turn in the middle of the street. I fell so hard in love with her. Yolanda was a down-ass chick for me. She'd show up to the work-release place, bring me my favorite food and all the news from Mapleton. We had a real Romeo-and-Juliet thing going, too, because as far as I could tell, her parents fucking hated me. I couldn't much blame them. I didn't have a lot of prospects, and I hadn't made the best impression even before I wound up incarcerated. Eric (nicknamed Boo) and Karen Sharp were great people, hardworking, and I was wild. I'd even borrowed Karen's car to go sell drugs in.

Besides Yolanda, the person I was closest to back then was this guy I met in work release named Otis Brown. This dude touched my life so much, man. He was like a mentor to me, so inspirational. He talked about the streets, and about trying to be a gangster, and he talked about those things in the past, like they were over and didn't have power over him anymore. Now he had a dream. He knew the way out.

I remember one freezing day in the middle of winter when he was whistling while he unpacked boxes.

"Why you so happy?" I said.

"I just did thirteen straight years in prison," Otis said. "And now I'm free."

This didn't look like freedom to me.

"Even better, I got a plan!" Otis said. "I'm going to start all the way from scratch. I learned how to cut hair in prison. I'm going to do $5 bald-head fades until I make enough to open my own place."

That was his favorite thing, $5 bald-head fades. He'd do them on anyone, anytime. He'd give your cat a bald-head fade if it sat still long enough.

"I'm going to come up," he said.

Otis also worked at Wendy's, so he'd be there all day and he'd cut hair at night. And he saved and saved his money. Eventually he got a job at a local barbershop, un-

til he got enough money to start his own, and I would go there and get my fade and sit and talk with him.

There was a guy who also used to hang there at the barbershop, Gary Bates, and he'd been to prison, too, but had gone straight. These guys became a good influence on me. We'd sit and listen to the radio, and I loved to make them laugh. When I did, Otis would tell me I belonged on the radio. Whenever guys got interviewed by the DJs, Otis would say, "You're better than they are, Mike. You got better stories and better jokes. You should be on that radio. You sure as hell shouldn't be out there in the streets."

Meanwhile, I had to make money, though. I couldn't imagine doing what Otis did, year after year of bald-head fades. I knew I was meant for something else; I just couldn't figure out what that was yet.

I spent my days just really confused. I didn't know really what to do with my life. I didn't know if I wanted to be a criminal. I didn't know if I wanted to work a regular job. I didn't know what the fuck I really wanted to do at the time. I was just trying to find myself, you know? But I wasn't doing anything to get there. I was just doing drugs, hanging out with my girl Pookie, and spending a lot of time at the barbershop, trying to make Gary and Otis laugh.

I moved into one of these big Midwest boarding-houses, with room and board. When even the boarding-house rent got to be too much, I bounced around from place to place, staying with folks I knew.

For a while I lived with my sister, Julie, then I ended up living with my brother John. That was going okay until one night while he was sleeping—he had to be at work at five a.m.—I borrowed his car to take a girl home. I got in an accident and totaled it.

John seemed more disappointed than angry. "You need to just leave here and do something with yourself," John said. "You want that fast money. You're taking too many risks. You're too adventurous. You need to figure out a plan soon or you're going to end up dead."

But I kept fucking up. I'd moved on, but one day I realized I'd left some drugs at Julie's house and I needed to get them right away. I went to Julie's but she was at work. I didn't have a key anymore and I didn't know what to do, so I got my tools and I took the door off its hinges. I propped it up next to the doorway. By that point I was late for something, and I wasn't thinking so clearly, so I just left the door there without putting it back on.

Well, Julie came home from work and found her front door leaning up against the wall. She wasn't real happy about it.

How she knew it was me, I don't know. "What in the

world did you do to my door, Mike?" she said when she called me.

"Sorry," I said. "I was in a rush. I had to get in the house."

"You better be glad I was living on the third floor and there weren't people walking by, or I'd have been robbed and I'd be even madder than I am at you," Julie said. "You need to get your shit together, Michael."

Things were getting real dark. I knew I couldn't keep doing what I was doing. By this time I'd already caught two drug felonies, and with one more I'd go in for thirty years. Even when I was on the straight and narrow, other guys in the neighborhood wouldn't let me alone.

Crime came to find me, even though I didn't have shit to steal. I couldn't even afford my own car, so one day I was driving my guy Jeff's drop-top car around. I was stopped at a red light when this guy suddenly appears and sticks a gun to my head. Fuck, I was mad, and I knew Jeff would be even madder when I got home without his car.

But I couldn't try to be a hero or I'd violate my parole. And I didn't want to get shot in the head. So I got out of the car. There were a bunch of guys there, and I'm guessing they thought I'd go get my friends, which I maybe would have; so instead of just driving off, they put me in the trunk.

Now, a word on this kind of car theft: It's not how we did things before 1992. But the Oliver Stone–produced movie *South Central* changed everything.

That movie taught America a lot: that gangs were everywhere, and very hard to leave; that it's hard to turn your life around. Oh, and it taught urban America something else: carjacking. That movie was the first time a lot of us saw anybody rob cars with a gun. Naptown learns fast. And that was how I ended up in these guys' trunk, maybe about to get shot.

Riding around back there, I was scareder than a motherfucker. I prayed to Jehovah, Buddha, Allah—every deity I could, lying there in that trunk. When the guy stopped at a stop sign and they cut the music down, I beat on the back of the backseat.

"What?" one of the guys yelled from up front.

"Play that again!" I yelled. "That's my song!"

That made them laugh.

I kept yelling stuff from the trunk to make them laugh.

"This guy's crazy," I heard one of them say.

Finally, after what felt like forever, the car stopped. Footsteps. The trunk opened. Was I about to get shot? I squinted up at them.

"You can go," the guy said.

I climbed out of the trunk, and they got back in the

car. As they were about to drive away, one of the guys held the gun out the window and pulled the trigger. A flame came out. It was a cigarette lighter.

Jeff never has let me forget that I got carjacked by some guys who had seen *South Central*, and with a cigarette lighter, no less. I blame Oliver Stone.

"You're better at comedy than crime," my friend Otis Brown said one day at the barbershop. "You're funny around here. Think you can go onstage and do it?"

All I had to do was find somewhere. We were listening to the radio one day and heard that Seville's—a cool old club where the NFL and NBA players used to hang—was going to have a comedy contest. There was a cash prize and everything.

"Hey, Mike," Otis said, "I bet you $500 you won't get up on that stage."

"Yeah?" I said. "You're on."

God bless Otis. I knew what he was doing. He thought I could make it, but he knew I'd only take the bet and get onstage if I'd be okay either way. If I failed, fine. I'd make $500. Otis was that kind of guy. He thought it was worth risking that much money just to get me to find out if I had what it took or not to take a chance on myself.

By the time I got there, the audience was drunk and ratchet, so I figured, *Why not?* and got good and drunk, too. By the time I got onstage, I was wasted. I stood there

and just smoked a cigarette and talked about my family. And every time I said anything funny, the audience laughed. And whenever I flubbed a line, they laughed. They didn't care what I said. They just seemed to like me up there. I liked being up there, too.

I blew that place up. I won the contest. I would have to go give Otis $500 of my winnings. But it was worth it.

THE NEXT DAY, I called 411 and asked for the phone numbers and mailing addresses for every major agency in Hollywood: CAA, William Morris, all of them, plus for *Def Comedy Jam.* Then I went to the post office and bought envelopes, paper, and stamps, and I wrote seven copies of the most honest, most personal letter I'd ever written. I poured my heart into it, said things I'd never told anyone before.

In the letter, I wrote that I was a comedian looking for an agent and a break. I told them I was twenty-two and I'd just gotten out of jail and won a comedy contest at Seville's, and that it made me realize all I wanted to do was perform. I knew I could be a star—I just needed a chance.

I was so honest that I couldn't imagine they wouldn't write back.

I waited a few days and then I called to follow up.

The operator answered the phone and said, "CAA."

"Hello," I said. "This is Michael Epps. Can I speak to the head of the company?"

"I'm sorry, but who are you?" she said.

"I'm Michael Epps. I'm a comedian in Indianapolis. I'd like to speak to the head of CAA about representation, please."

"It doesn't work like that," she said.

"Then how does it work?" I said. "Please tell me."

"To speak to the head of the agency, you have to at least have an agent here."

"Great," I said. "That's what I want, an agent. Can you help me get one of those now, please?"

"No," she said.

"Well," I said, "can you find out if my letter has been received? I sent a letter last week."

"I can call down to the mail room and see," she said.

I listened to the hold music and waited. I was sure she would come back and say, "Oh, Michael EPPS! Why didn't you say so? You're the one that sent that amazing, heartfelt, honest letter. We've all read it and everyone's fighting over who will get to be your agent. I'll put you right through to the very best one."

Finally, she came back.

"We get so many letters," she said. "No one knows if your letter is here or not. I'm sorry. Good luck to you."

Click.

I had calls like that with every organization. And I had them every single day, because I kept calling them all every day for months.

After the first couple of times, that CAA operator got to know my voice, and when I called, she said. "Excuse me, sir. I need to put you on hold."

She put me on hold and never came back.

Every day I'd call and she would do the same thing. I still kept calling.

Looking back now, I realize that this is not how you make it in show business. But what did I know? I was from Indianapolis. All I knew was what I learned in work release. So I did that, just trying to get a job as an entertainer rather than as a stock boy. I called like I'd filled an application out.

I never did get on the phone with an agent, but I did make one of the girls laugh on the phone at *Def Comedy Jam.*

"I'd like to talk to Russell Simmons, please," I said.

"You're crazy, man!" she said, laughing. "I've worked here a long time, and *I* don't even talk to Russell Simmons!"

People talk a lot about diversity: How can we make companies more diverse? How can we hear from diverse voices? Well, what I ran into maybe shows a little

bit how hard it is. They can't find us, and we can't find them. So the people who wind up succeeding are the people who are already around, the people who know how to play the game. They're not the best people—not at all—but they're the ones who get the jobs, because the really good ones are stuck back in their little towns, writing letters on loose-leaf paper.

People underestimated me because of where I was from. They'd hear I was from Indiana and they'd think I was square. This is something I think about all the time now when I'm around stars from the coasts: Good fucking luck surviving what I survived.

They wouldn't make it. They'll crumble. They'll realize how not-tough they are. They'll realize a whole bunch of shit about themselves, and it'll make them appreciate where they're from. If you came from California, or New York, or Chicago, any of them big cities where you got access to a bunch of shit, just know that you were born on third base; you didn't hit a triple. Bring your punk ass to my hometown, where it's fucking fucked-up. Yeah, become somebody out of that, motherfucker. People don't make it out of there because there ain't no fucking outlets. Where you out-letting at?

It kills me when I think about all the smart, good people I knew back in Mapleton, the ones who never had a chance, never knew what they could be or do. I think

about my friend Ryan's mother, Ms. Bembry. She reminds me a lot of Tupac's mom: street but so smart—a genius. She could have gone to Harvard. She was also an activist, so if the police were about to arrest someone, she'd come on the street and make sure they didn't do anything illegal. If the world were fair, the Bembrys would be running things.

But it seems like all the opportunities go to kids who already have everything.

Maybe we should establish a kind of reverse Fresh Air Fund, where rich white kids spend a summer in black public housing—trying to live on food stamps, figuring out which gang to join. It couldn't hurt race relations in this country, know what I'm saying? I'll start it. The Mike Epps Naptown Cultural Exchange Program. Bring your ass out here, New Yorkers and Hollywood folk. Come to Indiana—see how you do.

Respect the fact that I had heart to move to your hometown and become somebody. I never met your funk ass here.

Once I won that Seville's contest, I felt like I was basically at the top of Indianapolis fame. Seville's invited me back for a second performance, and I couldn't wait. This was going to be proof that I was the best comedian the town had ever seen, and I was going to make it.

Other people's expectations were high, too. In my

neighborhood I was an instant legend, and I invited everyone to this second gig—the whole neighborhood, my entire family, even people I owed money to. I'd been so drunk at my first show that I hadn't been able to enjoy it, so this time I was going up there stone sober. I was going to feel all the feelings. I was going to show them all how good I was. It was going to be this show, and then late-night shows, and then a mansion in Hollywood.

I bounced up onstage, as sure of myself as I have ever been, in a three-piece suit bought specially for the occasion. I told my first joke.

Silence.

I told my second joke.

Silence.

I told my third joke.

Boos.

I kept talking, starting to sweat in my suit, and nothing worked. I walked offstage to a smattering of pity applause from my family and groans from the rest of the room.

I bombed.

That was the last cue I needed to leave town. I needed a fresh start. I wanted to do comedy somewhere nobody knew me, so I could fuck up without having to hear about it for the rest of my life. I also had to go to a place where I could actually make it, where the stages were

bigger and the lights were brighter—not to mention to a city that wasn't full of guys who wanted to put me in car trunks.

I also had to go somewhere with the promise of a job, because shit was about to get really real: My girlfriend, Yolanda, told me I was about to become a father.

9

A COMEDY CLUB AND A
SEWER IN ATLANTA

The day my daughter Bria was born was one of the happiest days of my life. The second I saw her, I loved her so much.

"Damn," I said to Yolanda. "We got a *daughter*."

I could not kiss that baby's head enough—I kissed it over and over.

For the previous nine months I'd been in denial about being a dad, because it was such a huge responsibility. Deep down, from the second Yolanda told me she was pregnant, I'd been scared and I wanted to run from reality. She wanted to get married, get a house, all that, but I didn't want to do any of it. I was still running in the

streets. I didn't have no money. I was trying to find a job. I was hustling.

I didn't understand the magnitude of having a child. I didn't know how to be a father, a boyfriend, or a decent person at the time. When Yolanda got pregnant, I was still trying to sell drugs and living in a boardinghouse. And I was a bad boyfriend even though Yolanda always treated me nice. She did anything in the world for me. I wish I could've treated her much better. I just felt so much shame about not being there for her and the baby that I just did more drugs. I wanted to destroy myself.

But now, looking at Bria, I felt a change in me. Bria was so innocent, just this cute, fat, tiny girl with squinty eyes. She was just so sweet and beautiful. Looking at her on the first day she was alive, I was so fucking happy. Whatever bad shit I'd done, I'd done this one good thing: I'd helped bring this wonderful little person into the world.

Yolanda picked her name. We didn't talk about why she chose that name, but I think I know why. I wanted to be a comic, and Eddie Murphy had a daughter named Bria—I think that's why. I still had dreams of being in comedy, but the most important thing now was to get money for diapers.

Yolanda's auntie, Aunt Janet, who lived in Atlanta, offered to help. Aunt Janet said she could help me get a

job working for the City of Atlanta and let me stay with her for a while. That sounded good to me. Even though it would mean being away from Yolanda and Bria, I was happy to have a reason to get out of Indianapolis, to try my luck in a new city.

Right before I left, I went to see my sister, Julie, my second mama. She was babysitting Bria that day, so we took turns holding her while we talked. I told Julie I wanted more for myself and for my daughter, and that what I really wanted to do was be a stand-up comic. I said that I was going to work like hell to do it, that I thought maybe I could be a star and then I could raise Bria right.

"You'll do it," Julie said, "because you need to do it. Now, get out of town and make yourself a better life, because you're not going to have it here. Please don't stay here and end up messing your life up, Michael."

God, how I needed to hear that. It was like water in a desert. It's what I'd longed to hear back from all those agent letters I sent: *Don't worry. You'll make it. You'll be okay.*

Julie was raising her own baby, my little nephew, alone, and so she was on welfare. Even so, she reached into her purse and handed me a book of food stamps. She gave me a hug and promised to help look after Bria while I was away.

I left Indianapolis with $85 in food stamps, a Walkman with two cassettes, and a broken .38 pistol (it only fired every third time you pulled the trigger), bound for Atlanta.

Yolanda's aunt, Aunt Janet, was as good as her word: She let me stay with her and got me that job working for the city. Problem was, it was a job fixing sewers—an actual shitty job.

The job was not great, but I was just trying to survive. I'd been to prison, and anything was better than prison. Doing time was like being buried alive: At least when you're in a sewer you knew you could come back up for air again when your shift was over.

In my spare time, I was able to do what I really wanted to: work on my comedy.

I'd done my research and learned that the best club in Atlanta was the Comedy Act Theater. The place was owned by a guy named Michael Williams, and he was famous for booking the most incredible black comics. He made a way for everybody (the club launched Chris Tucker, for one). Williams put me off a few times, but I knew I'd keep coming back and asking him until he said yes, so I didn't take it hard.

I was in awe of how much talent there was at that club. I went all the time, trying to catch as many sets as I could, and to meet the comics afterward, funny people

like Earthquake, Chris Charles, a girl named Chocolate, Wanda Smith, Black Boy. I met this guy Nard Holston who was another up-and-coming comic, and we became good friends.

Finally, Williams let me go up onstage for open mike night. And I killed.

So I got to go up again. And again. And again.

And I never turned back. I started tearing their ass up every time at that club. Still, I had to grow. That's what a lot of people that are in the business that are new don't understand. You have to grow in this business. Even if you're a raw, funny guy, you have to put the work in and build up the stamina and the material. But I was working hard every day and I felt myself getting better every time. Even if I got booed, I learned from it. My jokes were getting better. My delivery was getting better.

I was also picking up some extra cash for performing here and there. I made my first $50 in Alabama when Nard and I got a gig there. Making that money sure felt good, and it was a lot more fun than hours in the sewer.

Speaking of which, I stopped showing up to work on Fridays, because it conflicted with my comedy schedule. That didn't prevent me stopping by on Friday afternoon to pick up my weekly check, though. They fucking loved that, as I'm sure you can imagine. In fact, they

fired me once, but then the following week they hired me back because they said I was good for morale. When I wasn't there, the guys didn't laugh at all, apparently, and they worked way slower. I was flattered, but I also really wanted to get to a place where I could quit that job and still make my child support payment for Bria.

Most of the other comics had day jobs or waited tables, and they were all broke like me, but that didn't stop us dreaming of making it big. We all told each other not to give up, and those other Atlanta comics became like my new brothers and sisters. The older guys were a different case, though: They gave us no love. In fact, they were vicious.

"You young motherfuckers think you're about to come in here and take our spots!" they'd spit. "Fuck you. You ain't funny."

One day I was doing a set and I was killing. Once I'd finished, I came offstage to see T.K. Kirkland. T.K. looked kind of like a street guy, but he was from New Jersey, and at Arizona State he'd gotten a college degree in communications. He had been on the scene forever, and he was filled with swagger and energy. Everyone always wanted him to emcee everything. That day he said to me, "You funny as a motherfucker."

"Yeah?" I said. I thought *he* was a bad motherfucker. To me, he was awesome.

"I like your raw shit," I said, "*My name is T to the motherfucking K and get your ass in the car.*"

"Man, you could really make it," T.K. said. "You're really good! But you ain't gonna make it in Atlanta. You think Atlanta's poppin', and it is, but if you want to make it—to *really* make it—you have to go to L.A. or New York." Then he added: "And if you want my advice, don't go to L.A. You need boot camp first. You need to train for this shit."

A lot of people will give you advice when you're starting out, but not a lot of them will actually back that advice up with action. But T.K. did: He put me on the phone with an agent he knew named Dave Klingman. I didn't know if I could trust some white guy from New York, but T.K. sold me on him, saying he was tough as shit.

I pictured a gangster, a tough guy who would push his way into clubs and put me up on the stage, tell everyone to shut up and listen. I liked it.

Eventually I got to talk to Dave on the phone and he asked me for a headshot.

Now, me being from the hood, *headshot* didn't mean the same thing: I flashed back to the Russian roulette games and all the other times I'd almost gotten shot. Dave must have sensed my confusion, because he said, "It's a photo."

"Oh, I can get you one of those," I said. Dave also said if I was serious about comedy, I should move to New York.

I was serious about comedy, but the timing was about as bad as it could have been. Bria was still so little, and new fatherhood wasn't going too well. Trying to be a superstar doesn't really go well with having a baby momma. I was sorry as fuck not to be there for her. But at the time I felt like I was doing what was right, and what would help everyone in the long run.

Then we got word that the Comedy Act Theater was closing. That was all I had going for me in Atlanta, so I got together with a bunch of the other comics—five others, including Bruce Bruce, Small Fry, and Nard— and we hatched a plan. We'd all move to New York City together, do clubs together, help one another out.

I had $1,500 from my sewer job tax refund. The other guys had some savings. We all made a plan to meet at the Greyhound station, ride up to New York together, make a go of it.

The day came. I showed up bright and early at the Greyhound terminal; I was the first one there. I bought my ticket and went to the gate and waited.

As it got closer and closer to departure time, I started to realize that not one of those five other muhfuckas was going to show up.

I waited until it was boarding time. That's when I was sure no one else was coming with me. Should I bail, too?

Fuck it, no. I went up to the driver and handed over my ticket.

Getting on that bus all alone, I felt crazy. Who did I think I was? I was leaving the South, all my friends, moving even further away from my little baby girl. For what? For a dream. For an idea.

The bus pulled out of the station heading toward New York. This was before cell phones, so I had nothing to do but listen to music on my Walkman and look out the window. Hurtling toward the big city on that bus those twelve hours, I kept thinking I might be making the biggest mistake. I felt as alone as I've ever been in my whole life. No one around me knew what I was feeling, or cared. I was all by myself with my fear and my dreams. The bus just kept heading northeast, into the rising sun.

BITING INTO THE BIG
APPLE—WITH
A BROKEN TOOTH

And then I woke up from a long dream on that Greyhound bus and I was arriving at New York's bus station, the Port Authority Bus Terminal.

It was 1994, and the city was still pretty grimy. People often say the Port Authority is where dreams go to die—it's not the prettiest place in the world—but that's where my dream came alive. My mom had showed me so many movies and played me so many songs about New York as a kid that I felt like I had already been to New York City, even though this was my first time.

At the bus station, I called Dave Klingman and asked

him to come pick me up. This was it! I was about to meet my new agent. From then, I figured, it was only a matter of days before I'd be famous. Before I'd left Atlanta, I'd psyched myself up. I was good; I knew it. Soon, New York would know it, too. I stood there for a while, buzzing with excitement, looking around for a limo to roll up and some baller with a pinkie ring to get out of it.

After an hour or so, I felt a tap on the shoulder. I turned around and found myself eye to eye with . . . nobody. Then I looked down. Standing there was this little guy who looked like Danny DeVito.

"*You're* Dave?" I said, obviously disappointed. "You don't look like a Jewish gangster."

"I'm not a gangster," he said with a laugh. "Who told you that? I *am* Jewish, if that helps."

We got in the car and went driving through slush and snow. When I saw the skyscrapers, it blew my mind. *Damn!* I thought, shaking my head. *I made it.* That was it. I thought I'd already made it, right then.

Dave pointed to the big buildings. "Say you're going to own all of that," he said. "Say you're going to run this city doing comedy."

That seemed pretty dumb, but I said, "Okay, sure." So I said it in the car. "I'm going to run this city doing comedy. I'm going to own all this." I said it a couple times, until I started to believe it. "I'm going to own that

building, and that one, too. And that store. And *that* building . . ."

Really, the most I was hoping for was to make it to *Def Jam* so I could prove everyone wrong, to show everyone that I wasn't just some thug—that I was somebody.

Dave took me to a hotel down on the West Side Highway. This was the 1990s, and the West Side Highway had no artisanal ice cream stands, only transgender hookers leaning into cars. The hotel's name was HOTEL. Just that: HOTEL. Behind the desk was a little Chinese guy. He charged me $35 a night, for which I got a room, a blanket, a toothbrush, and a towel.

Damn, I thought. *Am I in prison again?*

This hotel was beat *down.* The room was so small, I had to put the luggage under the bed first, then lie down. I had to share a bathroom with everyone in the hotel, and it was filthy, full of needles and syringes.

And at that point I realized I probably had not made it big quite yet.

It was time to work.

Dave picked me up the next day and took me to a comedy club in Brooklyn. Those were the days when Russell Simmons was producing the HBO comedy show *Def Comedy Jam*. From 1992 to 1997, it was huge. And who do I see in that Brooklyn club? All these comics I saw on TV, on *Def Comedy Jam*: A.G. White, Royale Watkins,

Cortez, who was funny as fuck. When Cortez gets done talking about your momma, you think, *Wow, is my mom really like that?*

Dave signed me up. This room was so fucking small, it might have seated eighty people. "Motherfuckers!" Cortez was shouting onstage. "Look at this motherfucker right here! Your lips so big, you could whisper in your own ear!"

The crowd was going crazy.

Then it was my turn.

"This next guy . . ." the MC said, ". . . you ain't seen in shit! I don't know who the fuck he is! From Atlanta, Mike Epps!"

I just started talking, in this country slur. My first two jokes got a little chuckle. Third one cracked 'em. *Pow.* Fourth one cracked 'em. *Pow.*

"You're pretty good," Dave said when I got offstage.

The next night we went to the Proper Café in Queens. A tough Queens crowd. Drug dealers sitting in the audience. Fly chicks.

I did jokes about my family, like: "I had a cousin so country that he had a cornbread wedding cake. Seventeen layers."

Cracked 'em.

Then Dave took me to a place called the Peppermint Lounge, in East Orange, out in New Jersey. Bill Bellamy

was the host. Naughty by Nature, Queen Latifah in the audience.

I did impressions of Ice-T, Tone Lōc, X Clan. I'd do anything for a laugh.

Cracked 'em.

I called back to Indianapolis. "Mom," I said. "I made it."

But things weren't quite that good. The whole time I'd been in New York, I'd been hanging out by pay phones, arguing with my daughter's mother, Yolanda, until I was down to my last five dollars in quarters. I tried to tell her that this was for all of us, not just me. That I had a shot. That it was going to work out.

"You got a brand-new baby and you're up there trying to be fucking famous?" Yolanda would yell. "Fuck you!" And then she would hang up.

I heard all those quarters roll into the back of the phone. My last five dollars—gone.

"Mike," Dave said, when I told him I was out of money, "you're really good, but you're still green. It's going to take a while before you're really good at what you're doing. I'm going to have to send you back."

Quietly, I packed my bags and Dave drove me back to the Port Authority.

I was in tears. I couldn't believe I had to go home. Maybe Yolanda was right. Maybe I was nothing. Maybe I would never be anything.

Adding insult to injury, this whole time in New York I'd had a busted tooth, because I'd gotten in a fight in Douglass Park in Indianapolis and ended up with this one tooth that was just hanging on by a thread. Now I'd never be able to afford to get it fixed. I'd never get to go anywhere or do anything. I'd be stuck in Indianapolis for the rest of my life. I'd been terrible at being a thug. Now I was going to have to go back to that life I sucked at, and I'd probably end up killed or in jail again.

I got out of the car. I started walking toward the terminal, slumped over, carrying my bags. By now I was sobbing loudly.

As I reached for the door to the Port Authority, I heard a voice behind me.

"Oh, Jesus!" Dave said, finally, calling me back. "Listen, you can come and stay with me for two weeks. Two weeks! But you have to find a job."

I moved onto his couch and stayed there for two years.

At one time Dave had managed all these great people, like John Leguizamo, Sandra Bullock, Guillermo Díaz, and Anthony Michael Hall (with whom I would later write a movie about being fake Muslims in prison, called *Don't Go Fakin' Your Assalamu Alaikum*, that for some reason still hasn't gotten made yet). It seemed to me that Dave couldn't keep these clients once they got

famous, because he wasn't part of a big organization and just worked out of his apartment. But he taught me so much. He and I became best friends, and he could really make me laugh. He was often the only white person in a club, and he'd totally stick out because of that and because of how he dressed, always in a sports jacket. If you gave him a hard time about it, he'd say, "I have to dress like this. I'm the *manager*."

Dave never had any kids, and he had for sure never been that close to a black kid in his life. It was the closest I'd ever been to a white man since the penitentiary. We were an unlikely father-son team.

We really were family, right down to the little fights we'd have around the house. For example, I kept noticing that every time he got back from the supermarket, the fridge would have watermelon in it.

"Why do you keep eating my watermelon?" he finally asked me one day.

"I thought you were being racist," I said. "I was eating it to teach you a lesson."

"No," he said. "I just really love watermelon."

"Well," I said, "in that case, next time you better bring enough for both of us, motherfucker."

Then, a big break: Bob Sumner, who discovered Steve Harvey, Ricky Harris, and a ton of other great guys, recruited me for a *Def Comedy Jam* show that was shooting

in Times Square. *Def Comedy Jam* gave black urban comics a way to make real money.

I got on *Def Jam* relatively early, jumped the line, because the way they chose the comics was originality. And no one else was like me.

I went down great with the *Def Jam* crowd. Russell Simmons, who cofounded Def Jam with Rick Rubin, capitalized on a sure thing: There were a bunch of funny motherfuckers already on the black circuit. Some of our greatest comics came from the chitlin' circuit, that bunch of venues around the U.S. that black acts could perform at during segregation and that even after integration were extra-friendly to African-American talent. Still, just about immediately, *Def Jam* comics got stigmatized for being raunchy. There was something to it: To do *Def Jam*, the more gutbucket you were, the louder the response you'd get.

Def Jam was a TV credit, which was crucial, but it came with some baggage. You'd hear: "Oh, he's just a *Def Jam* comic." Another term for that: "pussy-fuck comics." People thought *Def Jam* was synonymous with "Yo momma this, yo momma that, fuck you."

In those days, Dave Chappelle and Chris Rock were the mainstream guys and all other black comics were just *"Def Jam* comics." I was, like, *Why is it wrong for us to talk about fucking? That's what Eddie Murphy*

and Richard Pryor did! Why is it bad when anyone else does it?

To me, the stigma around *Def Comedy Jam* comics seemed like just a reason for us to be discriminated against and kept out of the mainstream rooms. But there was a freedom to those shows, too, though, so that felt so good. I'd wind up talking to people in the audience.

One time, there was this guy who went by the name of Zeus in the front row. He was giving me the stink eye.

"Who you looking at, dead-eyed motherfucker?" I said to him.

I kicked my foot in his direction. Then I lost my balance and fell down.

Well, a few years later Zeus and I would wind up in a movie together. His real name was Tiny Lister, better known as Deebo from the *Friday* movies and the president in *The Fifth Element*.

Once I had that *Def Jam* credit, my pay shot up, because now at clubs I was "You've seen him on *Showtime at the Apollo* and *Def Comedy Jam* . . . Mike Epps!"

I continued to work throughout New York, around guys like Martin Lawrence, who was so funny and raw and came from the streets like I did. I would get gigs paying $100, $175. In fact, black comics made way more money than white comics who were working more mainstream clubs like Boston Comedy Club, Comic Strip

Live, and the Comedy Cellar. They still just pay cab fare there.

I noticed a lot of the white comics could afford to work without getting paid, but not me: I had child support to pay. I had a big-ass receipt book and I had to send Yolanda the money every week. I would go from room to room, bar to bar, and I'd keep working until I had enough. I'd write those checks every time, without fail.

The vibe at the white clubs also wasn't really my thing. First of all, I'd find myself always feeling like I needed to dress up. I'd wear a blazer on nights I was going to a white club. And white people celebrate differently. When black folks laugh, they fall out of their chairs and stomp their feet and push each other. At white clubs, at best you'd get a polite titter from the audience. I'd walk off those stages sometimes and I couldn't tell if I'd done well or not.

So I had trouble relating in those white clubs. I mean, there are some black guys who understand white people, and there are some black guys who don't. I really don't. Whether it was the police or prosecutor or the judge, I just never understood how to accept people as people. You know what I mean? It's just a stigma in my head. Growing up, I always felt like white people treated my family like they were superior to us. It's just some-

thing in me that I've never gotten over. White people have always made me felt like I was doing something wrong.

Not like I wouldn't have liked to have tried those white comedy rooms. I did go check them out a lot. I'd see Jeff Ross, Colin Quinn, and Dave Chappelle perform and think, *I sure would like to be up there.* But I never quite could make it happen. Estee Adoram, the booker at the Comedy Cellar, would let me drop off my headshot, but it was still just a Polaroid, and I sure as hell didn't have an audition tape.

Lucien, this permed, skinny little guy who looked like Burt Reynolds, ran Comic Strip Live—the place where Richard Pryor and Chris Rock started—and he invited me to audition for him a million times, but he was hard as nails, and I never got in.

"Oh, Michael Epps? I've heard of you," he'd say just about every time.

I'd be like, "Oh, you've *heard* of me? I've auditioned for you three times in the last year, motherfucker!"

No dice.

Meanwhile, bookers like the Godmother of Comedy, Tina Graham, could get you on a chitlin' circuit of colleges and bar and grills that actually paid real money. She booked me all the time, and when Bill Bellamy started having success on MTV, she got me to sub for

him as host of the Peppermint Lounge. Real tough crowd, but I cracked 'em.

And from there I started getting college dates, and gigs performing at these cool ski trips that promoters would organize. It was a great setup: They'd hire a bunch of comedians to go to these ski resorts or vacation lodges—like Hunter Mountain or the Poconos—and we'd perform for a bunch of urban audiences.

None of us knew how to ski, so we'd all just party at the lodge. There would be a hot tub night, pajama parties, all kinds of theme events. Everyone drank and partied on the bus from the city to the place and then the whole weekend, and then on the bus the whole way back.

But it was really *Def Jam* that totally changed the game. Thank God for Russell Simmons, because back then there weren't a lot of black urban comics making it besides Eddie Murphy and Richard Pryor. He really blazed a new trail.

I'd always envied artists who grew up in major cities. They had so much opportunity. I felt so strong being from Indiana. It made me feel like *Goddamn, I'm from a place.* It's both a blessing and a curse.

But I still stood out like a sore thumb. I was doing stuff in my accent about parole boards and cornfields and everyone else was doing jokes about cabdrivers and the third rail of the subway.

They said all these things I'd never heard before.

They'd say, "There was mad bitches in that club," and I'd say, "That sounds terrible. Why do I want to go somewhere with angry girls?"

Everyone in New York was talking about the "super" or the "projects." My comedy was different, Midwest-driven. For a while I thought I should try to fit in, so I'd talk about New York. It bombed—people thought I was a country bumpkin, that's for sure.

The first time I got to do *Showtime at the Apollo*, the very show I watched back when I was in the county jail, I could hardly believe it. The night before the show, I could not sleep, I was so scared. It was a huge deal for me, and I wanted to kill, but it was terrifying for more than just me wanting to shine: *Showtime* was famous for the Sandman. He would come out and drag you off if you were no good. That was the last thing I wanted. Walking down 125th Street in New York City, past the African vendors and all the southern black folks, it felt like I was on my way to court to stand trial again.

In the greenroom backstage, I hung out with Kool Bubba Ice—a guy who did impressions—and Destiny's Child. Kool Bubba Ice kept saying: "You gotta bring it in the first three minutes!" and "Don't forget about the Sandman!"

I'm looking at this motherfucker like *I don't know*

why you're telling me what I gotta do. You gotta do the same thing.

Steve Harvey was the host that night, and I still remember him calling my name to come onstage. When I walked out, the place went fucking crazy. This was it. I was on fire.

"Sisters," I said, "you'll never see me with a white woman."

Huge cheer from all the women in the audience.

"That's because I bring my white girls out late at night. You'll be asleep."

I killed.

Right after the show, Steve Harvey was out front sitting in the limo with the door open. "Come with me," he said. "Let's go for a ride."

I was so nervous and afraid. This night was already the biggest thing that had ever happened to me, and I couldn't handle a heart-to-heart with Steve Harvey, too. Also, I thought of myself as a rebel.

"Naw, another time," I said. "I got someplace to go."

What an idiot I was. I think it was just all too much for me at the time. And I also think I thought the more rebellious I tried to be, the more attention I would get. And so I made my bed hard all the time. I thought that was the artist's way.

I should have jumped in that fucking car.

Instead, I went to a bar in the Village downstairs from the Greenwich Village Comedy Club and got wasted.

I owed so many people money that, once I got paid for the Apollo gig, I left town and disappeared for weeks. I went to Indiana, gave Yolanda some money for Bria, and got some overdue dental work.

I was pretty sure I'd get recognized on the street, too, and that I'd get a hero's welcome from my friends. Sure enough, my guy Otis Brown said, "I saw you! You killed it!"

But that was it. No one else had watched. And especially not Yolanda.

"*Def Jam*?" she said. "That ain't shit. That ain't *shit.*"

Things were terrible between us. My friend Jeff likes to remind me of the time Yolanda came over to my house with a baseball bat when I had another girl over. Luckily, the other girl was incredibly athletic and took the bat from Yolanda, telling her she'd whoop her if she didn't leave.

But I can't be mad at Yolanda. I wasn't much of a great father at the time. I paid child support and I visited whenever I could, but things were over.

Once, when I went by to see them, there was this little hustler dude hanging around.

"I been buying your daughter Pampers!" he said to me.

Right then and there, I knew the devil was on my ass. I wanted to kill that motherfucker.

But I knew if I did anything I'd go back to jail, and all I wanted to do was be on the road.

I was working on my material every day, everywhere I went. Some comics carry around notebooks and craft jokes on the page, but I never do. Sometimes I'll write a premise on a scrap of paper, like "Police," and then I'll just say all the jokes I can think up about the subject. Or if I was at a bar, I would look at the bartender and think: *Could I make "Bartender" funny as a premise? What do I have to say about bartenders? What about "Bus Driver?"*

One joke I told was about old men: "There's nothing like watching two old men fight. When old men get done fighting, there's a lot of change on the floor."

I've always told a lot of jokes about my family, especially my grandmother: "My grandmother used to call the police on everybody in the neighborhood. When the police came and got everybody rounded up, she'd go downstairs and say, all wide-eyed, 'What happened?'

"Your ass called the police on everybody. That's what the hell happened."

I had it all in my head when I got onstage, but I'd improvise even better jokes in the moment because I was terrified of getting booed off the stage. Most of my best

jokes came from fear. And my personality—people always related to me, felt comfortable around me—got me a long way.

But offstage my life wasn't so funny.

I was drinking and doing coke, and I thought I didn't have a habit because I kept my hair cut. If I had clean clothes on and a good haircut, I thought no one would know I was on drugs. What I failed to realize was that drugs adjust your attitude, not your look.

There was a guy who lived uptown who used to serve me. I'd call him as soon as I got offstage. He'd call the dope Eddie Murphy, as in "I got that Eddie Murphy outside waiting on you."

My highs would make me talk for hours about my feelings. Whoever answered the phone late at night would get it. One time I got high and called my mother: "Mama, I got one question: Why did you fuck Daddy?"

"You must be high," she said, and hung up.

Every time I got high and came down, I'd get sad and start crying until the dope man came back, and I'd say things I wouldn't have said when I was sober. I thought it was helping me—opening up my third eye—but really it was destroying me. I could have been so much greater than what I was without all the drugs.

But I needed to drown out all the pain, and I was really insecure. The drugs let me pretend I was someone other

than who I was and live my lie better. It made me look and feel bad while I was doing it, sure, but it also gave me an alter ego, and my alter ego was killing it.

Even when I wasn't high, I still felt like I was living a dream, a dream I prayed I'd never wake up from. So many years I'd find myself thinking, *Is this really real? Did I really come to this? Or am I still living in Indianapolis on Twenty-Third Street and just asleep and dreaming?*

I just had to tell myself to keep going.

11

ACTING LESSONS ON MADISON AVENUE

Every night I felt like I was getting better. I could feel myself winning over crowds little by little as I improved my jokes and played off of them.

Here's an example: One night in the Bronx I did a gig at this place called Jimmy's Bronx Café. It was Monteria Ivey's show, "Monty's Crib." Monteria was known for snaps like, "His family was so poor they used to go to Kentucky Fried Chicken to lick other people's fingers."

So I got up there for my spot and started talking New York:

"The Bronx. The Boogie Down Bronx . . . Steel, concrete, bricks and shit . . ." I talked about how kids in other parts of the country get told to go play outside and

that means climbing hills and running through fields, but in the city it's just "Play on the steps!" That's all they have, like two stairs to play on.

No one was having it. Quiet crowd. They looked older, so I changed my stuff.

"We got some older folks here tonight," I said. I told them I was going to talk about sex anyway, because "Y'all done the same shit that we done when you were our age. My grandmother got thirteen kids by four different men. I know she's sucked a dick."

Now the crowd was starting to laugh.

"I don't call you old. I called you *settled.* Nothing bothers y'all."

I talked a lot about my grandmother being two-faced. She'd be sitting on the porch when a girl we knew walked by, and she'd say to me, "Look at that ugly black bitch. I can't stand her." And then she'd put on a smile and sing out, "Hi, baby! Don't you look pretty today!"

I talked about how my grandmother always talked shit about '90s women. "Nowadays, girls can't cook. They only have two, three babies."

To which I said: "Who wants to have seventeen kids and cook all the fucking time?"

At that point, people were laughing hard. And I kept them going. I made fun of people in the crowd: "Look

at her running to the bathroom like some little Gremlin motherfucker!"

This one really killed:

"The women in New York like to walk up to you and squeeze compliments out of you. They say, 'I'm getting fat.' And you're supposed to say, 'No, baby! You look so good!' I don't play like that. I say, 'You are. You really are. No wonder. Every time I see you you're eating.' Then she says, 'I'm big-boned.' To which I say: 'You're big-biscuited.'"

Once I'd said *big-biscuited*, that crowd was mine. "Women are good, though," I'd say. "Women are something else. Without women, we'd die. Where would we be without women? Bunch of guys in Timberlands and hoodies, pregnant on the corner, smoking weed . . ."

Then my time was up, and I left to big applause, a drink ticket, and at least $75. In ten minutes I was making what it took me a week to make at the 7-Eleven back in Naptown.

I kept thinking, *I love New York.* Things were going great. I was working all the time, even winning competitions. But I also needed someone to keep me right.

Just before I was about to move out of Dave's, he told me he had a friend from Oklahoma City who used to be a street guy, Thomas Cobb "T.C." Carl grew up in

L.A., but his parents are from Oklahoma and that's where he went to college on a football scholarship and studied business. He came to New York City and was only supposed to stay for two weeks but then stayed for the whole summer. He'd gotten a job at a fancy law firm defending the tobacco industry; the law firm gave him tickets to the ballet, the theater, sports. That's how he started meeting people in show business, like Dave Klingman and T.K. Kirkland, which is how I got hooked up with him.

When I met T.C., he was Mike Tyson's friend, Anthony Michael Hall's friend, knew Sandra Bullock, he knew all these people. I was a street guy, too, you know, so I think Dave wanted T.C. around to keep an eye on me.

Dave called T.C. and said he should go see me perform.

T.C. didn't know so much about comedy, but I would learn that he knew all about the pitfalls of being famous. He understood about the self-doubt, and the ways suddenly having money can fuck with you, and all the ways you can get in trouble.

The first time he saw me—some place in midtown—he walked in right as I was going onstage. It was still true that no one would mistake me for a New York comic in those days: I came out there with my Indiana accent and a cigarette dangling from my lip.

I'd say things like "My grandmother did a drive-by—on a tractor" and use words like *n'er nother*—"My grandmother said, 'Don't you get a n'er nother Popsicle out of that freezer!'"

When I finished that night, T.C. hadn't stuck around, so I thought he'd hated it. The truth was, he'd left to call Dave.

"He's a star," T.C. had said. "He doesn't even need jokes. He's just funny. I fell out! He's going to be a star."

"Yeah," David said. "He's going to be a star. But right now he's still an unsuccessful thug. He's a criminal, but he's not smart at it. He needs help. Can you keep an eye on him?"

We met, and he became my road manager—the best. It's a friendship that's lasted for decades.

I quickly moved into his apartment, and he set me up. When he took me to the grocery store, I loaded up on chicken, vegetables, flour, sugar, rice, and beans.

"I thought you'd go for the Little Debbies!" T.C. said.

"No, man," I said. "I can actually cook. My mama taught me."

When I went to Dave's to pick up my stuff, I left a couple of jackets behind but took my shoes. T.C. took one look at them and insisted I donate them to a homeless shelter. I did so reluctantly. At the shelter, the old guys shuffled into a line to each pick out a pair, see if

they fit. When T.C. wasn't looking, I got into the line myself: I wanted to get my Jordans before anyone else took them.

"What are you doing?" T.C. said when he saw me nearing the front of the line.

"I just want my one pair of Jordans back," I said.

"No, let them have all the shoes," T.C. said. "It's okay. Walk away from the shoes. There will be more shoes in your future. Better shoes. I promise."

T.C. didn't lie—there were more and better shoes.

And there were some great parties. Thanks to him, I was living large and making fancy new friends. Tracy Morgan was doing a show, *The Uptown Comedy Club*, on TV, and we used to ride with him. Tracy was a star. He had a hat with a propeller on it. Me and Tracy became friends, and one time he was picking me up from T.C.'s and he looked around and started teasing me about how rich I must be living there. I had no money at all and hadn't really noticed.

"Nigga, do you know where you live at?" Tracy asked me.

"Madison Avenue?" I said. "Does that mean something to you?"

I guess it was pretty nice. The apartment was furnished in the latest style: a green leather couch, glass tables. T.C. also did a makeover on me. I put on some

fancy suits and started showing up at clubs and people would say, "Damn, who *is* this?"

T.C. was a role model to me. We would sit and argue about who was better, Miles Davis or Tupac. I was for Tupac. T.C. turned me on to jazz and I turned him on to rap. We challenged each other in everything: wrestling, basketball, running. T.C. became my best friend. He was a loyal friend. I'll never forget everything he did for me.

T.C. seemed happy when I was reading books. I'd carry around some big book by Friedrich Nietzsche.

"Did you read it?" T.C. would say.

"Yeah, I'm reading it."

Then he'd see me a week later, still carrying the same book, bookmark in the same place, and he'd say, "Are you reading that book, or are you just carrying it around to look cool?"

I even started taking acting classes, but I wasn't learning much. My acting partner in the class didn't take me seriously at all. There's an old video of one of our scenes and I'm cracking jokes, getting laughs, and she is rolling her eyes at me.

I learned a lot more at home, where T.C. would set up a little video camera and we'd do scenarios, improvise. T.C. had done drama classes in high school, so he would give me scenes to act out: "You're going up for parole, Mike." Sometimes we'd have other guys over, like this

comic Ray Grant, and it would be: "You're his parole officer, Ray."

I'd get right into it, put on a cap and Malcolm X glasses and get out my copy of *Message to the Blackman in America* and say, "They say I raped them boys in the penitentiary. I ain't never done anything to nobody. Sir, all I'm asking for is another chance. I'm good as gold. I joined the Nation and everything. The Nation don't take no bullshit."

We were like kids. We'd film these scenes all over T.C.'s building, up on the roof, all over midtown. We'd dress up in wacky costumes (like I'd put on tall black socks, a black leather jacket, and a crazy cowboy hat, plus a purse), pretending to do cocaine deals, passing around baby powder and dollar bills.

When I got a role as an extra on *New York Undercover*, I was so excited, you'd have thought I got my own TV show. Even if I didn't get to say anything, it was a big moment.

"Did you see me on TV?" I'd ask all my friends.

"Uh, I saw you walk through the scene," they'd say.

"That's right!" I'd say. "You saw me! It's on and popping! I'm on my way! I'm gonna be a big, big star."

Never mind that I didn't get but a small fraction of the shit I auditioned for.

"You're not getting down, are you, Mike?" T.C. would ask me.

"No way," I'd say. "Rejection I love. I love them to tell me no. That means when the yes comes it will be that much bigger."

In the mid-1990s, I got cast in an indie movie called *Strays*, which was written and directed by and starred Vin Diesel. We filmed a lot over at the Fashion Institute of Technology on Seventh Avenue in Manhattan. I was so excited, I got a unicycle and would ride it from T.C.'s apartment to the set all the way along Thirty-Fourth Street every day.

I even got a little role in the first season of *The Sopranos*, playing the boyfriend of a guy who stole a car.

I almost got the lead role in this Def Jam movie *How to Be a Player*. The director flew in to see me do a show at the Flamingo on the West Side. That was a crazy night: Biggie was there, Puffy, too. I did a tight set, and I was sure I'd nailed the part. Little did I know, Bill Bellamy was already cast as the lead and the director was on his way out of the movie.

Between gigs, though, T.C. would wake me up at some reasonable hour and say, "Get up! Write some jokes!"

Once he even got me a job working demolition. I lasted until noon. T.C. really chewed me out for that, but I was

so focused on being a comedian. I was working my ass off—seven shows in a night. I might start at seven p.m. at Catch a Rising Star, then I'd go to the Uptown Comedy Club (lots of New York sportsmen went there). Then I'd take the train out to Long Island to do a club called Nakisaki, then all the way back to Manhattan where I might even get the PATH train to perform around two a.m. at the Sphinx in Roselle, New Jersey.

Some nights I'd be doing a set at the Boston Comedy Club or some shit, and along the back wall there was Chris Rock, Dave Chappelle, and Tracy Morgan, just standing there, watching.

One day I got asked to join something called the Creative Tour, a comedy tour all through the chitlin' circuit rooms in the South. We hit Virginia, North Carolina, South Carolina, Atlanta, Birmingham, and straight up to Memphis.

Only one problem: My license was suspended and I had no car. T.C. said, "I'll give you my car and $20 for some gas. Drive like an old lady."

Well, in that Mazda 929, I rolled from New York to Norfolk, to Richmond, to Charlotte, to Atlanta, to Memphis. Each club was so different from the others. But I learned that it was easier for me to make southern crowds laugh than New York audiences. New York audiences are like dogs. An aggressive dog will walk up to

you ready to bite, and if you act scared, he'll bite harder. In the South, I didn't stick out so much with my jokes about my rural family—they got me.

Eventually, I was ready to get back to a big city: I felt like I'd graduated from boot camp. But what next? T.C. had an idea: "What are you still doing here?" he said. "You *did* New York. There ain't nothing else for you to do here. You're ready to go to L.A."

"I'm not ready," I said. "Dave Chappelle told me, 'Don't go to Hollywood until they ask for you.'" Dave had a nice place out on the West Coast. He seemed to know what was up.

"Maybe Dave wants you to stay here so he'll get all the jobs," T.C. said.

The only thing left that I hadn't done in New York was *Saturday Night Live*, and that was never an option for me. It just wasn't my scene; I'm too untraditional. So I started to think that maybe L.A. was the answer.

My friend Red Grant out in L.A. told me that I could stay with him. I had been to California, but only to the Bay Area for a comedy competition.

A lot of people in New York have an unreal perception of Hollywood. I'd heard so many people talk bad about it. When you hear that all the time, then you already got your nose turned up before you even land, like, *Fuck this place.* You don't give it a chance.

But T.C. and Red talked me into it. They told me—and it would turn out they were right—that if you're in the business, Hollywood is the true land of milk and honey. And it's also one place that looks more at what you do than where you came from. It's one of the only places in America that they'll let anybody in if they're talented. You can be in a nursing home full of old people, and if you got a good script, they'll buy it. I'd learned everything I could from the New York clubs, but L.A. was calling me.

I bought another bus ticket.

I thought my life over so many times on that bus ride from New York to California, just as I had done on the bus from Atlanta to New York. The weather outside was lousy, then it was fine: sleet, snow, rain, sun. Sundown. Sunup. I saw mountains and lakes and deserts. I rolled through states I had never been through.

Then, in Missouri, police pulled the bus over. When I saw the lights, I was scared as hell. *They're gonna come get me for some old shit,* I thought. Would I ever truly escape?

When they boarded the bus, they walked directly toward me. I was scared to death. I tensed up as they got to my row. Then they kept walking and snatched some guy right behind me.

Damn, man, I thought, *we came so far, and got so far to go.*

12

AN AUDITION AND
A FUNERAL

When I arrived in Hollywood in 1998, it felt to me like a whole new world.

I knew I might be here for a while—at least, I hoped so. First, I moved in with my guy Red. We started trying to write movie scripts together and we went out together each night to comedy clubs. People were really happy to see me in L.A. "Man, you should have been here for years!" they'd say.

I auditioned during the day and did comedy at night. I'd always loved movies, so I wanted to get film work. It took me a long time to figure out auditions. Once I realized that auditions were just a room with a person in it, things got easier. All I had to do was meet that person,

or those few people, and see if we could get along. I mean, I was ready: I had the skills, I just didn't understand the audition process right off. I came in trying to be the character all the way, right away. Sometimes you don't have to be a character when you're auditioning—you can just be you, and you can find your way into the part. That's one of the strongest positions you can come from, just being yourself and getting them to like who you are. Then they have faith that when push comes to shove, you guys can work it out about how exactly to play the role.

I'll tell you something that never got easier, though: the competition. One of the crazy things about auditioning is you walk in and you see your peers in there all sitting in the waiting room. Guys you know and are friends with. Everyone's sitting there, looking at each other like *Who's going to get this?*

Most of your competition is friendly until someone asks the dreaded question, "What you reading for?" If you're reading for the same part, an iron wall comes down. And all of a sudden it's time for the game face and a look that says, *Talk to you later. Obviously, we can be friends again one day, but we ain't friends right now.*

When the pressure was off, though, L.A. people sure knew how to have fun. One time I was at a cookout at

a big apartment complex with my guy T.C. There was a big pool in the center courtyard. I kept looking from the apartments to the pool, from the pool to the apartments. I knew what I had to do; it had to be done.

"Hey, Mike is missing," I heard T.C. say a few minutes later. "Where's Mike?"

"Here I am!" I yelled, and I jumped off the third tier of the apartment complex into the pool, sending a huge cannonball of water up into the party. I got out of the pool and everyone was laughing, yelling, "You crazy, man! You're fucking crazy!"

The first movie I booked in L.A. was called *3 Strikes*, directed by DJ Pooh. The movie is about a guy who's just gotten out of jail and is trying to stay out but is in a tough spot, because he already has two strikes against him and the state has a three-strikes-and-you're-out rule.

When I met DJ Pooh, he said, "Damn, man! I wish I could have cast you as the lead role, but it's already cast. I'll get you something, though." I really didn't care how big the role was. I just wanted to be working. I ripped that cameo.

"I'm in Hollywood now!" I said to myself as I rode down Sunset. *This town is gonna make you or break you,* I thought, *and it feels so far like it's making me.* Right

away, I loved it there. Honestly, doing all those comedy rooms in L.A. was a piece of cake compared to New York, where I'd had to ride three trains to get to gigs every night. In L.A., I'd just drive and I didn't even have to park, because everywhere had valet service. California was all sunshine and flowers.

I was feeling good, too, because I had a lot of good friends and my family seemed so happy for me. One time I was staying with my sister, Julie, and her son, and I realized after I left to go get on a plane that I'd left a bag of money in the closet. Old habits die hard: For a long time I didn't trust banks and would carry all my movie cash around.

I was in a panic when I called Julie. "Please tell me I left the money there. I can't find—"

"Calm down," Julie said. "It's right where you left it in the closet." She never opened it, counted it, took anything out of it.

Those are the kind of people I need in my life. I was so glad I'd left my thief friends behind, because they'd have taken and spent that money by the time I'd gotten to the airport.

I was working the clubs all the time, every night, and auditioning during the day, looking for my big break. But I found time to have some fun, too. You know, they

had all kinds of beautiful girls who used to just come to the comedy clubs. One in particular, Elena, became something: We'd hang out at her apartment a lot. She liked my Indiana accent.

And I made some great friends. My favorite was this tough guy named Comic Strip. He was always chewing gum and looked like a cartoon character; that's how he got his name. He was a great guy with a good heart. And when I hung out with him, it was all good times and parties.

Comic Strip knew all the bad guys in town, but he tried to get me to stay away from them.

"Mike," he'd say, "what the fuck are you doing hanging with these guys? You're trying to do something with your life. You don't know what the fuck they involved in. If somebody comes back to get them, they gonna get you, too."

But I couldn't help it: The bad guys were so fun, and I felt comfortable around them. In particular, I was hanging down on Crenshaw at this guy's house, which was an after-hours spot. He was really smart and respected and loved in L.A. I used to go over there and get high and cry—all mouth twitching and eyes flickering—and he'd say, "Motherfucker, don't come over here and get high no more, 'cause you don't know how to handle it."

The coke wasn't the problem; my *mind* was the prob-
lem. The shit that was going on in there didn't mix good
with cocaine, you know. I didn't know why I was still
doing cocaine, even. It would make me depressed. Co-
caine only really worked for me the way it's supposed
to about three days after I'd come down from it. That's
when my fucking creativity was crazy. It felt like it just
opened my mind up. I'd come up with jokes. But on ei-
ther side of that moment, it was depressing, man.

Meanwhile, at the clubs, I found the crowds to be so
different in L.A.—way more lighthearted compared to
New Yorkers. I would come out and go onstage and kill.
You could tell the comics who hadn't been through the
New York clubs, too, because they were way greener. It
made me glad I'd come up the way I had, because it let
me take everything in stride when I did festivals like
Laffapalooza.

Laffapalooza—America's Urban International Com-
edy Arts Festival—was run by Jamie Foxx, Marcus King,
and his wife, Jaime Rucker King, and it all hung together
thanks to their road manager. When we had been on the
Def Jam tour together, that guy had rooted for me. "That
dude, that's the next Richard Pryor," he said, and that's
how I got the Laffapalooza gig.

Around the same time I met Niles Kirchner, who was
working at King Entertainment for Marcus and Jaime.

I wasn't sure Marcus King and them really wanted the company to manage me, but Niles thought I'd be good, so they let him take me on as a client but made it clear, "He's on you, Niles."

I was still wild as fuck. I'd had other managers before, but most thought my personality was up and down. No shit. Anyway, it was hard for me to get representation, and things didn't really last until Niles came along. I think it's because he's from L.A. He's a black guy, but he went to Beverly Hills High, so he was around nothing but white kids. He was the closest thing to a white guy that I could get—a black guy who understood white people. I was, like, "You know what? I haven't met a white person that understood me." So here I got this black guy that knows white people way better than I do.

So there I am at Laffapalooza, and I fucking killed. Niles was looking for how to turn that success into something more, and at the time everyone knew that Ice Cube was looking for a guy to replace Chris Tucker for the next *Friday* movie. Every black actor on earth wanted that part.

Niles set up a time for me to audition in front of Ice Cube at the Comedy Store.

I killed it.

Then they had me in again. I killed it.

Again. Killed it.

Still, though, no offer. I started to go a little crazy. I thought I was gonna get it on the first day. I didn't know you had to do it a million times for a role.

So I'm killing myself trying to get this part, and then Elena drops a bomb: She told me she was pregnant.

The timing wasn't great. I was just trying so hard to make it. And I was already paying child support on Bria and missing her. I didn't think Elena and I were going to get married, and it made me sick to think about having two kids out there I wasn't seeing all the time. But as soon as I saw my daughter Makayla, I was just so grateful to have her. She's the spitting image of me; she's like my twin.

Now that I had two daughters to support, the pressure was really on to get that part in *Next Friday*. This was no time to mess around. Week after week, though, they kept having me in and still I wasn't getting that part. I was starting to freak the fuck out.

Then more shocking news: Out of nowhere, my little buddy Comic Strip got killed. Someone shot him in L.A. I'd seen him right before it happened. I couldn't believe that was it, that he was gone.

I went from Comic Strip's funeral to yet another audition for the fucking *Next Friday* movie. T.C. and I drove straight to the studio from Forest Lawn, crying

like shit, drinking Hennessy, changing clothes in the parking lot.

I thought I was close to having the role. *This could turn things around,* I thought. *I could do it for Comic Strip.* But when I walked up to the building, I saw every actor in the world who looked like me out there practicing my lines. Wayans brothers. Wayans cousins. Wayans acquaintances. Fucking everyone.

"Is this some fucking joke?" I said to T.C. "I just left my homie's funeral and I'm back to square one on this thing? And now I gotta go there and be funny?"

But I pulled it together, went in there, and nailed it again. I nailed it for Comic Strip.

T.C. and I were driving back home to his place when we got the call. We hadn't even made it to the I-10 and T.C.'s phone rings.

The part was mine.

T.C. and I looked at each other like *That's it.* That's the moment we'll always remember, when I went from a comic to a star. I'd beaten out a parking lot full of more famous guys and I was going to be in *Next Friday* with Ice Cube. I could pay off my debts. I could tell everyone I grew up with who said I'd be nothing that they could suck it. I could show the world what I could do. This was the break I'd been waiting for all this time.

In that car, I felt like my life was really starting. I got my phone out and I called everyone I ever knew and told them that I got the role.

My buddy T.C.—who's been with his Joanie since forever—was always saying to me, "Why don't you have a steady girl?"

So, on this day, I had an answer: "Hey, T.C.," I said. "You know what? Now I *do* have a steady girl. Her name is *Comedy*. She'll never forsake me as long as I don't neglect her."

I was so moved by that idea that right there in the car I gave a little speech:

Your art is like being in a relationship. You have to spend quality time with it. You can't leave it for a long time and come back to it and think it'll still be there. You have to be faithful to it. You have to give it all you've got. As much as you put into it, that's what you get out of it.

Comedy saved me. I'm never giving up on comedy. How could you not be faithful to something that saved your life? That pays you? It's always there, no matter who else runs out on me. God gave me the gift. It's almost like they're hand in hand in my heart: comedy and God, because the gift came from Him. Good, God, gift—all the *g*'s.

I've always had the attitude that I won't lose. I'm a fighter. When I get in hard situations, I fight hard. And so, that's been my life: Challenge after challenge. Blessing after blessing.

T.C. said, "You do know, right, that you still have to film the fucking thing?"

13

FOREVER DAY-DAY JONES

I was so scared I was going to fuck it up. It was a do-or-die situation for me. I was entering into a movie that was more than just a movie—it was a cult, so huge—and Chris Tucker, the guy who was in the original with Ice Cube, had been incredibly good. It was a lot of pressure.

For the time we were going to be filming, they put me up in a hotel in Valencia. This place had high-thread-count sheets and room service and a view. I was wearing a brand-new watch that a guy at CAA, my first agent there, had given me, and new clothes. I felt so good. But when I checked in, the script was laying on the bed and I realized it was all really happening, and I was going to have to *work*.

"You'll be great," Cube said when I met him on the set

in South Central. He could tell how scared I was. "Don't sweat it."

The *Next Friday* plot centered around a guy, Deebo, a bully who gets out of prison. To get away from him, Craig (Ice Cube) moves out to the "fake-ass *Brady Bunch* suburb" of Rancho Cucamonga, California, to live with his uncle Elroy, who won a million dollars in the lottery, and his cousin Day-Day: me.

When I walked on that set, everybody just went quiet, and I could swear every one of them was looking at me so disappointed, like, *Sure wish we could have got Chris back.*

The first scene I did with Ice Cube was the one where my baby mama sprayed me with some Mace and I had to tell him about meeting her and about her stalking me.

At the end, the director called "Cut!" and there was total silence. I was sure I'd fucked it up and was about to get fired.

You know, when I started in Hollywood, I didn't like to audition until I realized that—guess what?—you're gonna have to do it in front of these people anyway. Even if you get the fucking job, you still gotta prove yourself, motherfucker. Every day that you show up on the set, that's the audition again; but it's even worse to fuck up on set, because they've already hired you.

So I stood there on the set of *Next Friday* listening

to the total lack of laughter around me, and I thought, *I'm going to have to call all my friends, and my mom, and say I got fired.* Almost worse: T.C. had gotten a job there working as an associate producer, and so if I had to leave, he'd probably be screwed, too.

Ice Cube was standing there. He must have known it was bad, but he wasn't saying anything.

"That was bad, huh?" I asked him. "Nobody's laughing."

"It's not the time for you to be funny," he said.

"What do you mean?" I said. "It's always time for me to be funny."

"No," he said. "This is the establishing scene of me and you. Don't worry about being funny right now."

Then it *was* time for me to be funny, and I remember coming out of the house and I saw John Witherspoon, who played Craig's dad, Mr. Jones, sitting behind the camera. He had this look on his face like *Motherfucker, you better be funny.*

When they said "Cut," John wasn't laughing. I was, like, *Fuck.*

Time for another take. I had to make it happen now.

Second time I came downstairs, I killed that shit. John Witherspoon laughed his ass off. And it was then I knew I was going to keep that job.

That was one fucking blessing, getting that part. I

paid off some back child support and some old loans. And over time I got comfortable acting, and Ice Cube and I got to be friends.

There are long breaks between scenes when you're filming, and a lot of standing around. During one break, Ice Cube and I were there in the doorway of a kitchen, waiting to start shooting again. I didn't want to go on too much about all his songs, but I was a fan, so I was trying to be cool. Quietly, though, I started beatboxing one of Cube's old songs. It took a few seconds before he noticed; he smiled and started quietly rapping over it. I got louder and he got louder and then we were doing the whole song, full voice.

When that movie wrapped, I couldn't wait for it to come out. I was so proud I'd done it.

New Line had a private jet and it took us around the country to promote the movie. There I was, me from Naptown, traveling around with Ice Cube. That was my first time on a private jet. I couldn't believe it.

I kept saying to T.C., "We're on a jet!"

One of our bookings was on Queen Latifah's talk show. She was an iconic figure to us at that time. It was amazing to hear the teaser: "Coming up next: Ice Cube, talking about his movie *Next Friday*!"

Ice Cube went out there in his *Next Friday* shirt and sat with her on the chairs. He talked about being in

N.W.A and his family. He talked about his work with kids: "If you don't love yourself, you gonna fall victim to yourself." He said, "It's not always easy, and I think it's not even supposed to be easy."

Finally, I was up. Queen Latifah introduced me as his "hilarious co-star, Michael Epps."

I ran out there with my big jeans and my *Next Friday* sweatshirt.

Queen Latifah asked me how I got cast.

"I was performing at the Comedy Store on Sunset and Cube saw me do my thing."

"He's a pro," Ice Cube said.

"You looked real comfortable," Queen Latifah said.

She said Chris Tucker did an amazing job and got his start with the first film, and that I did a good job following in his footsteps: "You've stepped into that new character like he would have been."

"I'm glad he didn't do it!" I said. "I just approached it like it was a role. Ice Cube said, 'Don't even worry about that, man.' Kids be saying, 'Is Smokey going to be in the movie?' I said. 'No, Smokey's in rehab.'"

I was learning how to play the game, and traveling with Ice Cube was great; we did straight-up hood shit. We played basketball and shot dice and smoked a lot of weed. And it helped getting to do publicity with him so when I went out by myself I knew what to do.

The only downside to being in *Next Friday*? I get called Day-Day Jones on the street every goddamn day of my life. It's going to say DON'T CALL ME DAY-DAY on my tombstone and everyone walking through the cemetery's going to be like, "Oh, and over there you can see the grave of Day-Day."

"How long will I be Day-Day?" I recently said to a packed crowd in D.C.

"FOREVER!" they shouted.

It gets a little old, getting called Day-Day all the time. But you know, I can't complain. Because being Day-Day got me that house and it has saved my life at least three times.

The first time was at Home Depot. I got in an argument with this little Mexican guy over some nails or something. Well, I walk out of the store and all of a sudden ten Mexican guys were there waiting for me in the parking lot. The main guy was six foot three. I'd never seen a six-foot-three-inch Mexican before. This was some kind of custom-made Mexican. He said, "You tell my nephew to go fuck himself?"

I tried to say no, but then the nephew comes along and says, "Yeah, that's him!"

The giant Mexican stares at me and I notice that he not only has teardrops tattooed on his face, he has so many that they drip down his neck and past his shirt's

neckline. They probably drip all the way down his fucking body, an ocean of teardrops. And he's getting closer and closer to me.

I'm about to beg for my life when he gets close enough to get a good look at me and says, "Wait. Are you Day-Day?"

Now I get called Day-Day on the street all the time and I tell people to stop calling me Day-Day.

But standing in that Home Depot parking lot, I saw things differently.

"Yes! That's me! I'm Day-Day!"

I sang the *Next Friday* theme song. I danced. I did the lines. The Mexicans laughed their asses off, and that's the first reason why I'm alive today.

The second happened in the spring of 2000 when my guy and I went down to San Diego to visit with T.C.'s sister and family. We wound up grabbing half a bowl of loud green,* so we were feeling pretty paranoid.

I can't remember exactly how, but after our family visit, we got in my truck and ended up at a Mexican border checkpoint—you know, like you do when you're high and holding. We did *not* want to be there, but by the time we saw where we were, it was too late to turn around. If you spot a NO DRUGS ALLOWED sign and immediately

* If you are a police officer: *loud green* is slang for *California souvenirs*.

do a U-turn and peel out, the cops tend to think something's up.

So we decide to just go for it. We're heading into Mexico. No problem.

At first, we're good. We're rolling through the checkpoint, just being cool. They're going to wave us through . . . But no. At the last minute, a Mexican border patrol lady officer waves for us to pull over.

Fuck. We didn't even plan on going to Mexico. Now here we are, almost definitely going to jail in a matter of minutes. We pull over and roll down the window. We must smell like a forest. But then I see the agent recognize me.

"Well, if it isn't Day-Day!" she says.

"Yes!" I say. "Day-Day! That's me!" And I start doing every joke from *Next Friday* I can think of.

"I'm here to borrow some sugar!" I say in Day-Day's voice.

She starts laughing. I keep going until she's doubled over cackling.

"You guys have fun," she says, waving us through.

"Damn," my guy says as we pull away. "Look at that. Your ability as an actor just saved you from how bad you are at being a criminal."

"Why are you surprised?" I said. "That's the story of my life."

We turned up the music and drove into Mexico.

And the third time that movie saved my life happened about a year later.

Do not try this at home.

Jeff and I were back in Naptown, out west off of Twenty-Seventh and Clifton, in an area called the Land. We were hanging out, smoking a blunt, just cruising around, when we come up on a bunch of kids pushing and shoving and calling each other names. I was going to keep driving, but then I was just like *Naw!* I stopped my truck on Clifton.

"Uh, Mike?" Jeff said.

But I was out and around a lot now. I was famous. I wondered what kind of power I had back home, if maybe I could make the place better. I thought of myself when I was a kid. I wished someone had tried to make me do better. I wouldn't have listened to them, probably, but it still would have been nice.

"Hey!" I shouted at the kids.

They turned and looked. They were about to run or to come fight me, I know, but then they recognize me from *Next Friday* and start getting excited.

"Day-Day!" one shouts. "What you doing here?"

"Going to see a friend at the barbershop," I say. "Now let's talk a second."

I told them they should stop fighting each other. Shit's

bad enough without that. They have to find what they're good at, I say, and find a way to get out of this. They don't want to be like this forever, right? I keep talking, trying to get through to them. They're nodding, but I could tell the second we got back in the truck they'd start punching each other again.

"Tell you what," I say, "if you be nice, I'll give you a hundred bucks apiece."

Now they're listening.

"What's the catch?" one said.

"No catch," I said. "Just I don't want you to fight. If you don't fight, I'll give you the money."

They looked at each other.

I took out my wad of money and their eyes got wide. I peeled off $100 for each of them.

No big surprise: Another dozen kids materialized up out of nowhere. But I couldn't not give them money when they never fought to start with. What message would that send? So I give each of them $100, too.

They start freaking out, shaking my hand, patting my back, saying thank you and I'm the best and all that. But that's not why I did it.

"I love you, Mike!" one of them shouted after us as Jeff and I got back in the truck.

I couldn't stop smiling. I was so glad I was famous

and so glad I had that money. It was the best way to spend it, giving back to my old neighborhood.

Right after the movie had wrapped, I had gone back to Indianapolis and had knocked on the door of the house on Carrollton that we got evicted from, the one with the white picket fence.

A man had answered the door. He and his wife had bought the house and were raising his family there.

"I used to live here," I said.

"Okay," he said.

"Listen," I said, "I used to live here as a kid and we got evicted. Now I'm in show business. I would like to buy the house from you."

"Well, we're not selling it right now," he said.

I was really disappointed.

"Okay," I said. "I'll try again another time. Thanks anyway."

And once again the door in the fence clicked shut behind me.

I was worried that I'd never get to buy the house. I was also worried I'd never get another movie role, in fact. Because here's something not a lot of people know: I got in a fistfight at the *Next Friday* wrap party, with one of Ice Cube's bodyguards, Big Sleep.

Well, actually, Big Sleep got in a fight with some other

guy first. I saw him fighting and I just jumped in, started fighting with whoever I could reach. I was just a hood motherfucker. I was on drugs at the time, too. I was doing coke a lot. But it was a stupid thing to do. And I think it really fucked my relationship up with New Line Cinema. After that, I felt like they looked at me like *Oh no, we thought he was a real actor, but he's a fucking heathen.*

It was a dark time. I was getting roles here and there and I was playing clubs and I was getting better and better, but the whole time I was on coke, and I was doing two- and three-night binges. I used to do coke so much, I couldn't sleep for days. I'd be up for three days, mouth dry, hungry, depressed, crying one minute, laughing the next. Happy, talking shit. I had, like, four, five different personalities going at once.

And just like before, I'd call home to talk to my mom, and once again she could hear it in my voice.

"Why you doing this to yourself?"

"Because I'm tired," I'd say.

"Listen," she said. "Being tired ain't enough."

"Well, what else I gotta do?"

She said, "You've gotta be tired of being tired. Being tired ain't enough. Takes two of those. Two tireds."

I wasn't there yet. I was still functioning. I hadn't hit bottom. I felt sure I wasn't an addict. I mean, I have an

addictive personality, but I didn't love cocaine. I did it, but I never loved it.

I knew guys that would do drugs and they weren't depressed or nothing; they were just, like, "So, what y'all doing tomorrow? Let's do coke again."

But I was the type of dude that when that shit came down . . . Wooo, that's the worst fucking feeling that you ever want to have in your life. I wouldn't put that on my worst enemy. It was like being in hell. I'd get songs trapped in my head. Whatever song was the song at that time, I couldn't sleep, because this song was just in my head.

And voices.

It was pure misery: I couldn't sleep and I wasn't hungry, and when I finally woke up, it would just be pitch-black in the room and my mouth would be dry and I felt so bad, because I said so much fucked-up shit and did fucked-up shit while I was high.

My conscience would show up, like, *Why would you do all of that shit? What's wrong with you? Why you putting yourself through this shit? This is not going to make you more funny. This ain't gonna make you happy.*

But I think I didn't feel I deserved to be happy after the life I'd led. It was just a cycle of shame. The only thing that made me feel better was work.

And, luckily, I was about to get plenty of that.

14

"REMEMBER THE TIME"

No matter how rough anything was in the rest of my life, I always showed up on time and worked hard to get it right. Work made everything better, and distracted me from things I didn't want to think about.

I did so much fun stuff. There was *How High* with Method Man and Redman—I came in originally just as a writer to punch it up and help make it funnier but ended up appearing in it, too. In 2000, I shot a movie in Toronto called *Bait* with Jamie Foxx. He plays this small-time thief who gets caught stealing some shrimp—sorry, *prawns*—and then the cops use him as bait to catch this bigger criminal. I love that movie. And at the time I had a publicist who was this beautiful Ethiopian chick who I ended up being in a relationship with. (Elena and I

were no longer together.) But she kept trying to make my life better. And when women try to make me better, that's when I get stubborn and do everything to be the opposite of what they're trying to make me. She wanted me to work out more; instead, I started eating a ton of potato chips.

Not long before he died, Bernie Mac did a movie with Samuel L. Jackson called *Soul Men* (slogan: "Out of Sync. Never out of Style") about two soul legends who get back together for a show at the Apollo. Bernie was funny as hell; I was so happy to have a role in that movie, just so I could meet him and learn from him. Between sets we would sit and talk. I had him on the floor because I did impressions of comics from Chicago that he came up with.

"Give me some advice," I told him.

"Cover your own ass," he told me. "Or someone else will. Take care of your mind, body, and"—I thought he was going to say soul—"your *money.*"

Shooting the first *Hangover* movie, in which I played mistakenly kidnapped "Black Doug," was like being around a bunch of guys hanging out after school. They were just cracking each other up. I don't think anyone knew that movie was going to be as huge as it was. I got brought back as Black Doug not long after in *The Hangover Part III.* Those guys showed back up having made

some money and they had better haircuts, nicer clothes, and cuter girlfriends.

Around that time, I got a serious role in a movie called *Sparkle*, directed by Salim Akil. The movie was about a young girl group from Detroit in the 1960s. I think a lot of people in Hollywood don't understand that I'm just a better serious actor than I am a comedian. This was a chance for me to show my shit, you know? And I do a lot of homework on the character. I reach back into my past. I knew so many big personalities growing up that it's easy for me to tap into a role. I still have all those people from my old neighborhood, all those people's voices and walks and histories, all at my fingertips.

We shot *Sparkle* in Detroit in the wintertime, so it was cold as hell, but I was so grateful every minute I was there. One of the greatest things about it was that Whitney Houston was in it.

This shit they said about Whitney being sort of crazy? She was a total pro from what I saw. And she was magic. That voice! Jesus, in person it's even more amazing than you think it's going to be. Once I walked by her trailer and out of the window I heard her doing a duet with Michael Jackson to "Remember the Time." He was coming out of speakers, but it sounded like he was right there in the room with her. I still get chills when I think about that.

One of my favorite movies I've ever made was *All About the Benjamins*, another film with Ice Cube. T.C. had gone around trying to get someone to make that movie for a while. He and the writer went in to meet with Magic Johnson to see if he'd be in it, too.

"Who's going to star?" someone on Magic's staff asked.

"Mike Epps," T.C. said.

"What's he been in?" they asked.

"*Next Friday* and *Bait*," T.C. said.

"That's one and a half movies," said the staffer.

(Magic turned the movie down—he did a movie with Mos Def and Queen Latifah instead.)

But Ice Cube was in, so it was all good. We shot the movie down in Miami. I had so much fun on that set, but sometimes it was at the expense of my fellow actors. For a start, they bring in a really professional actor to play Mr. Sheldon. He's a *thespian*.

As the cameras roll, I start improvising, and the professional actor hates it.

"Cut," says Kevin Bray, the director.

The Mr. Sheldon actor says, "Are we changing the lines?"

Everyone else liked what I was doing, though. Bray said to him, "You deliver the lines the way you want to and so will Mike."

So the guy delivers his lines.

I improvise again: "Mr. Sheldon, Imma quit coming here. Imma start going to Dwight!"

"Dwight who?" the actor says, exasperated.

"Dah white around your lips!"

(He had a white beard and mustache, get it?)

They kept it in the final film.

While we were filming that movie, I got a call from a friend of mine back in Indianapolis.

"You know that old house you're always talking about? The one on Thirty-Third and Carrollton? It's up for sale."

"Whoa," I said. "I got to have that shit."

I got a broker, and the broker went to the owner. The neighborhood had come up a little bit, so I ended up spending about $80,000 on it. But I bought it. Finally.

I went to Indianapolis. It was eerie, pushing my way through the fence, walking into the yard. I opened the front door and walked inside. That's where Chaney and I wrestled. That's where my mom fed us SpaghettiOs. That's where we watched TV and I saw Eddie Murphy do Buckwheat for the first time.

I went to my mom's house and told her I had a surprise for her. I drove her to the Carrollton house.

"This is your house now, Mom," I said. "You can live here again. No one is ever going to take it from you. It's ours. We own that shit."

"You bought this house, Mike?" she said.

"Yeah," I said.

"You bought it with the money you made in Hollywood?"

"Yeah," I said. "I bought this house with the money I made acting. I want you to live here again. I'm giving you the house. It's yours."

She was quiet for a minute.

"I'm real proud of you," she said. "That's real sweet of you." Then she got quiet. "But, Mike, I'm sorry, I ain't moving in there. That time is gone, baby. I can't relive none of that shit. I ain't doing it."

Where I remembered wrestling for fun with Chaney, she remembered fights with Reggie. She remembered worrying about her kids having enough to eat.

I was sad she didn't want to be there, but I understood. That was a dark time in our lives. I wanted to fix it, but it's not so easy. Instead, I gave the house to my sister, Julie, and her son to live in. And I kept buying up property in the neighborhood.

My grandmother had moved out of her house and retired to Florida. She had sold the house to one of the guys who went to the Kingdom Hall of Jehovah's Witnesses with her, a brother named Marvin Johnson. He'd told my grandmother, "If you ever want this house back, I'll sell it to you."

I called him up.

"Hey, Marvin," I said. "Ms. Anna Walker wants the house back."

I moved my aunt into that one.

I bought the whole block and a lot across the street. Every movie meant another house.

Owning property for me is about saying I made it. I became somebody. Those deeds mean a lot to me. I guess it's because I came from that neighborhood, made it out of there, and now get to go back and say, *You don't own me anymore, Mapleton. I own you.*

Back when I was a kid there, me and my friends, we didn't get a lot of recognition for who we were. In fact, there was nobody there to *give* us recognition. If we were great, we didn't know it, because nobody told us. Going back there now, taking care of people, that lets me say those people were great and maybe I was, too.

A MOMENT FOR THE
WOMEN IN MY LIFE

I've always been a lover. The women in my life, I must say, have really contributed to my madness and my happiness. I could remember dating this girl, Jo-Jo, in junior high school. I could have had a kid when I was fourteen or fifteen, but it just didn't work out that way. I like ladies, what can I say? Not a lot that's appropriate for a book, you know?

But anyway, in 2006, I thought it might be time to settle down some, marry my girl Mechelle.

I met Mechelle one day while I was walking around the Fox Hills Mall. This was in the early 2000s, when I was doing the *Friday* movies. I was living in L.A., out by the airport. So I'm at the mall, probably walking off

a hangover, and I saw her right off. She was shopping with her friend, and I walked up to them in a store. I'll never forget her friend thought that I was going over to talk to her, but I wanted to talk to Mechelle. It was a little awkward. I had to be, like, "Sorry, not you. Your friend."

"Where are you from?" I asked Mechelle.

"Houston," she said. "You?"

"Indiana."

"My dad's from Indiana!" she said.

"Wow," I said.

"And his name is Mike, too."

"Wow!" I said.

We had a connection right then. And then we dated for a while, and really fell in love.

Still, it was hard deciding to get married.

I'm a romantic. I've always had this woman in my mind that I wanted that I'd never met. All the girls that I've seen weren't the woman that I had pictured in my mind. Only I can see this imaginary woman. I get glimpses of her in my head. You keep trying to get as close as you can to that imaginary woman. And with my wife, I thought I finally was really close.

Looking back, there were some warning signs. I did have some fears, you know, like that she said she wanted to be an actress. Being in a relationship with somebody that wants to be something, it's a lot of re-

sponsibility on you, you know? You need to help them. I felt like I had to help her with her career.

Another fear I had was that I felt like she didn't want me to have anything to do with my friends back in Indiana. That made it hard for me to have a relationship with my family, too. She didn't seem to want me doing anything for, or even with, them.

"I don't know what you're going back there for," Mechelle said when I said I wanted to go visit Indianapolis. "There's nothing there."

But Mechelle was a beautiful person. She seemed like the woman for me, so we decided to have a big wedding. I paid for my family and her family to all go to Hawaii for it. It was the biggest, most expensive wedding ever.

It rained.

"I heard rain on your wedding day means good luck," Mechelle said.

Well, it wasn't.

We had some good times and two amazing daughters together: Moriah, who's five years younger than Makayla, and Madison, who was born two years after Moriah. They're smart and beautiful, and I'm the luckiest father in the world. They're extensions of my mother. They remind me so much of her. When you have kids, you try to figure out who they're going to be. You can't really figure it out while they're still young.

But you see glimpses. And I see so many glimpses of my mom.

But long story short, eleven years after we got married, Mechelle and I got divorced, in September 2017. We'd been separated since June of 2015. She's my kids' mother, so I don't want to say anything bad about her. And I wasn't a great husband, I'll admit it.

The thing that's hard, though, is our two young daughters. I hated leaving the house where they live.

If you're keeping score, that's right: I now have four beautiful daughters. Four. I don't know how I didn't have any sons. Maybe fucking while wearing dress socks? Four girls—can you believe it? It used to bother me, like an ego thing, that I didn't have any boys. Where is the mini-me? But now I know it's a blessing. It's made me a better man. For so many years, I was talking shit about bitches and hoes, not respecting women like I should have. Now I look at my girls, and I see so clearly that I have to throw that sort of talk away.

Some of my daughters have just started dating now. And I have to deal with something people told me for years but that I didn't want to believe: Girls find guys who are like their fathers. So now my daughters are bringing these guys home, and I do not like the looks of them, and it's because they look like me: "Daddy, meet *you*!"

One time I knew this dude my daughter brought home had weed. I could just tell. I thought about lecturing him or throwing him out of the house . . . but I really needed some weed. So I asked him if he had any.

"No, of course not, Mr. Epps," he said.

I was walking out of the room and right before I got out of the door he said, "But I know where to get some."

I turned back around.

"Is it good?" I asked him.

"Yeah," he said. "It's loud."

"How the hell you know the word *loud*?" I said. But I gave him some money and he came back . . . five minutes later. Yeah, he totally knew where to get some—his fucking glove compartment.

When my daughter stopped dating him, it was a relief. She doesn't need to be running around with bad kids like that. Sure miss that pot, though.

I've had to learn to be a good father. I didn't know what it looked like, a good father who was there all the time. So many men in the black community take off. My dad did it; when I became a father the first time, I did it, too: I for sure wasn't around enough when Bria was little. That's a real source of regret for me. Then I got married and I thought I wouldn't do it this time.

But I did. I did it even though I knew firsthand how much it sucks growing up without your dad around all

the time. I'm sorry my dad wasn't there much when I was growing up. And I'm trying really hard to be there for my kids now as much as I can be even though I'm not with their mom anymore.

I'd still get married again. And I still really want to be a good father, a good role model. I'm trying to make it up. I talk to them every day. I check their Instagram all the time to see what they're up to. I give them help when they need it.

I got tested on this when my daughter Bria had a daughter, Skylar. Skylar's the cutest thing in the world. Bria will dress Skylar up and put makeup on her and she looks 45. Talks like it, too. She's so smart.

Skylar's dad left. The difference is: Bria has me. I told my daughter, "I'm going to take care of you and that baby." And I do.

What's crazy, though, is that if I hadn't left her and her mom when I did, to go to New York and try to be a comedian, I don't think I ever would have gotten famous, and then I never would have made enough money to take care of my family now.

It was the wrong choice and the right choice at the same time. That's why this stuff is so confusing. You never really get out of school, you know what I mean? The only difference is that you're an adult now. School was very, very challenging for me because it wasn't fun

enough, and I want life to be fun now, too, only some-times I have to be a grown-up and deal with hard shit.

Being a grown-up has given me a lot of love and re-spect for my mom. I always thought I knew who my mother was until I became an adult and I started to re-alize how hard things were for her and how brave she was. And I started to learn more about her childhood and more about the family, and to see what she was up against.

My mom's still in Indianapolis. And know what's crazy? My mother and my stepdad Reggie are still married—they've just been separated since right around when my baby brother was born (and he's now thirty-seven). My sister and brothers and I think of all our dads, he's the last one she should still be married to, given the way it ended and everything, but you know, these things are complicated.

My mom's got a lot of health problems. She has chronic COPD, asthma, and bronchitis. But she's hang-ing in there. Not too long ago, she was diagnosed as schizophrenic, which explained some things we'd al-ways wondered about. Sometimes she'd just say crazy shit. Julie, especially, had a lot of fights with her back in the day. She'd say things to Julie and later not remem-ber she said them. How could my mom say those things when we knew her to be so sweet? Well, the diagnosis

made it make sense. And now she gets shots for that and is a lot more stable.

My grandmother's living the good life down in Florida now, too. She's about ninety. I fixed up her old house real nice. I brought it back to its original design, made it pretty beautiful. My auntie runs a home day care there now.

My brothers and sister are doing good. I mean, we all have a lot of scars. As you might imagine, I think it messed Nathan up pretty bad being left like that and raised separate from his full brother, Aaron. But we're all doing surprisingly well, all things considered.

Chaney works at a juvenile court, if you can believe that. Every day he sees kids like he and I were. Well, like I was. He was always a good kid. The stuff he tells me about the Indiana kids today is crazy. He's still my fan and still my friend.

Chaney's over at our dad's place a lot these days. Tommie Sr. isn't in the best of health since he had a stroke, though he takes care of himself much better now than he used to—no drinking anymore or any of that.

My brother John has been married for twenty-five years and has two beautiful kids in college. He was working as a printer for twenty-seven years (he even got me a job there once; I lasted a day), before that industry

tanked. Now he's a surface miner, working with sand and gravel. He's a good, hardworking man.

My sister, Julie, takes my mother for her shots and does everything else for her, too. Julie's so good at taking care of people. When Julie first moved into the old house at Carrollton after I bought it and my mom didn't want to live there, it was hard on her, reliving those days. She almost left. But now she's settled in. She works part-time in customer service.

Julie took care of her father, Robert, when he was sick and dying of bone cancer, and now she takes care of our mom. I try to make sure Julie's taking care of herself, too. It's so easy when you're taking care of people all the time to forget to take care of yourself. I especially see women in our community do this all the time. I got her a gym membership, and she says it's helping her feel stronger. Julie always says that "the Good Book, the Bible, it says you reap what you sow, and you have to watch how you treat people." I hope that's true for her sake, because she's done so much good, and she deserves good things.

Through all these years, my mother's voice has always been in my head keeping me safe, telling me one day it would be okay. She always wanted better for us, but for a lot of our childhood I think she just didn't know how to make it better.

Still, even though she was always struggling, my mother taught me so much about how to have manners and how to survive. I know how to cook because of my mom. It blows people's minds. They don't expect me to know how to cook. An urban comedian guy. But I can *cook*. I know how to work on cars, too. My mom was always all for us learning as much as we could about everything.

We had it really rough for a really long time, but she found ways to make it okay for us—to get us fed, to let us know we were loved. For all the horrible shit in my childhood, thanks to her, it wasn't all bad. If you have people around you like her, and if you can figure out a survival strategy, you can get by. I always say, even though I grew up dirt-poor, my life wasn't just one thing. It was a gumbo, a collage. And she raised me to be sensitive. That made me not so good at hard crime, but it made me a better person and it let me find my real talents.

I love my mom so much. I can smell her scent even when I'm not around her. I can't even describe it. It's like flowers. Or air. It's just my mother.

And she helps me whenever I'm struggling. My mom has always told me: "You want to deal with something? Go to bed." Every day, she said, life repeats itself. When you sleep, it's like you die for eight hours. Then, in the

morning, you come back to life and you get another chance.

Life is a redemption. Every single day you get redeemed. All you got to do to be saved is go to bed. Every time I go to her with a problem, she says the same thing: "Go to bed. Go to sleep. Tomorrow you'll get another chance. Tomorrow it will be different."

Without her voice in my head, I'd be dead now. My mother most of all taught me a lot about people. She always said that you can't change who people are. You either have to love them and accept them, or don't fuck with them at all. You can't stay in a person's life and change them.

She used to always tell me, "You haven't lived so long," and I never knew what that meant. She was basically saying that you never live long enough. You don't have to sit in the shade. You'll learn till you die, and you haven't lived long enough to understand everything. I hear so many people talking about wanting to make it. Unfortunately, you never really make it. Or you do, and then you just live to fight another day, right?

16

HOLLYWOOD IS STEPHEN DECATUR HIGH SCHOOL

When I was younger and bill collectors would call the house, I would mimic a white man's voice. It was an important skill to have.

"Why, yes, sir, that check is in the mail!" I would say in my crisp, white-person voice. "Well, ma'am, I'm afraid that woman no longer lives here. How sorry I am you are having trouble collecting from her!"

I've often been asked, first in school and later in auditions, if I know how to talk without using slang. Of course I do—that's the voice black men use in a job interview, or when they're talking to the boss, or dealing with a judge. That's the bullshit you have to use when you get pulled over by the cops. When you see those

lights, especially when you know you have some guns or drugs in the car, you think, *Time to talk like a white person. Maybe he'll let me drive away.* He comes up to the window, you smile, and say, "Good evening, Officer!" and then you pray.

Remembering who you are and what your soul is can be hard in Hollywood. I try to stay true to myself. I once walked off the set of a TV show because they had us shooting at a real slave plantation. In the scene I had to get into bed with a white girl, but when I got to the set, it just didn't feel right. I was looking out into the woods and it was like ghosts of former slaves were haunting me. I took a break and called my grandmother to tell her.

"You leave, baby," she said. "You don't need that money."

And I ran like an escaping slave off that set.

I've always hated people who wanted to be popular. Hollywood reminds me of Stephen Decatur High School so much. The kids in high school who were at the popular table were always people that didn't have no real talent. People like that weren't shit to me. That's how Hollywood is to me, too. The people who are just funny enough or talented enough are the ones who are popular. But the best ones are always somewhere else.

In the fall of 2016, I wound up in Montreal, Canada, playing Dr. Chris Salgado in the *Death Wish* remake

starring Bruce Willis. Now, there weren't a lot of black doctors living around us back in Indianapolis when I was growing up, but I was able to play a doctor because very early on I learned how to transform myself into someone who could get by in any situation.

So I used the skills I honed figuring out how to talk to cops and judges and lawyers to pretend to be a doctor—but now, one thing is different: Now that I'm an adult, I know I can be articulate as *myself*. I don't have to play a white person. I can talk like a smart, doctor version of myself without necessarily pretending to be white. It sounds like a small difference. To me, it's huge.

Filming *Death Wish* in Canada during the 2016 U.S. election was especially refreshing because I got to see America and its politics from the outside.

I love America, but being in Canada made me think about how free I am and also to ask some questions like: Is it *really* free? The answer is no—you gotta pay something for it. And growing up black is still detrimental to a person's safety. Racism is all over the world, but I think you can feel it more in America.

Growing up in segregated Indiana, I used to be intimidated by people from bigger cities. But when I was hanging out in Montreal, I realized something else: Being from Indiana made me who I am—and I'm no less than anyone else. In fact, I think about people I used to

look up to and I realize that now I've seen more of the world than they probably ever will.

As a comedian and actor, I've been all over the world. I ran through L.A. and New York like water. I ran through Detroit, too. Where you belong is about heart and individuality and it has nothing to do with landscapes or where on the map you start. It's not about where you're from; it's all about who you were born to be.

I tell kids all the time: If you can't imagine it, it's hard to get there. You have to have a really advanced imagination. If you don't dream it, it won't happen. On that bus from Atlanta to New York, all I did was keep dreaming, my head mashed against the greasy window, coming up through the Appalachian Mountains, up the East Coast. And it got to be where the whole world started to seem like a dream to me. Awake or asleep, it was all the same: I was just dreaming.

I have to remind myself that a lot of people in the business went into it wanting to be famous. Not me. Because of how I grew up, I never expected to have anything, and I can work with whatever I have. If I get two dollars, I'll have more fun than somebody with a hundred. I've never been that type of person who's greedy for fame or money. I got into this for just one reason: because I really enjoyed making people laugh. I enjoyed it so much, I realized I couldn't live without it.

Still, you have to be strong to make it in Hollywood, because you get rejected all the time. Like when he made *Ride Along*, Ice Cube traded me in for Kevin Hart—that Webster-size motherfucker!

Then there was the time Katt Williams tried to diss me and I gave it right back. He is one crazy, firecracker motherfucker. He and I were about to do another movie together, and beforehand I showed up at a show we were going to do together, and he was in front of the theater waiting for me, doing that pacing thing of his.

Instead of saying hi, he yelled, "You couldn't drive up in a newer car?" Then: "You got my old jokes in that big trunk?"

"No," I said. "I got a little kid in there who could beat you up just like that seventh grader you tried to take in Gainesville." (He'd just lost a fight to a child and it was all over YouTube.)

We've battled a lot over the years, and because we had street people around us, it could have gotten ugly. But while I'm writing this, we're getting ready to star together in a sequel to *Meet the Blacks*.

Shit talking is just part of the game. It's fun. Here's some more of it:

Remember when Dave Chappelle got all that money and went to Africa? Just so everyone knows, you give me fifty million dollars, I promise not to go to Africa. I

will go to the mall, yes. I will go to the car dealership. Africa? Naw.

Who else? Ice-T. Ice-T did some mighty bad acting on *Law & Order*. Every episode they only give him, like, two lines and then you don't see Ice-T again until the end: "Homicide says three kids are missing. We still don't know what happened." And out.

I can laugh at myself, too, though. You know, I had a network TV show for about five minutes. People went from calling out "Uncle Buck!" to "What the fuck . . . happened to your motherfucking TV show?"

I was test-driving a new car when I got the news that it got canceled.

"What do you think?" the salesman said.

"I think I can't afford this car anymore," I said.

I still feel out of place in Hollywood. When I go to awards shows, I don't know what to do with myself. I usually find a corner and just lean on a wall. I can tell people are scared of me, and that's an uncomfortable feeling. They're either afraid of me or they don't take me seriously. (I don't know which is worse.) Coming from where I come from, the worst thing is not being respected. The only reason why I want a motherfucker to be scared of me is so you won't disrespect me. That's where all my tough shit comes from. I don't want you taking advantage of me.

So if I'm mean, that's why. I've been mean in my life because of that. And people misunderstand me for that. They look at it, like, *Damn, he's an asshole.*

Well, earlier this week I came in the door nice and three people took advantage of me. (No names, but they know who the fuck I'm talking about.) Shit, everybody in the business knows who I'm talking about. I'm talking about basically everyone. So tomorrow I'm gonna be an asshole, because I don't want to be taken advantage of again.

I wonder if it would be different if I was 350 pounds, or if I was five-two, if I wasn't just a strong, fit, six-foot-two-inch black man. I wonder what I'd have to look like for people to actually see who I really am, to see my feelings, and my compassion as a person. Because the way it is now, people are judging me off how I look and how my confidence is through the roof, and they can't see that at the same time I'm insecure. So I got enough confidence to stay in the business, but maybe I'm too insecure to become the biggest star.

Hell. All I know is sometimes I feel like I gotta dumb down around people. But it's a lose-lose proposition. If my personality is too big, I scare people off. But when I dumb down, they take advantage of me. How the fuck do you win? I don't know what to do. There's no happy medium.

Truth is, there's a double standard for guys like me. The good shit that I do, no one says shit about it. So I'm, like, *Damn, does the business want me to be a bad boy, or what?* I gotta walk around this motherfucker on eggshells, because there's this invisible sorority of people that you get in trouble with, you know? You'll get in trouble with these people if you do anything. So just don't do shit. Lean on the wall. Try not to talk.

Throughout my whole career, I been giving back. I go to juvenile detention centers, talk to kids, feed the homeless. Does anyone ever say anything about it? Naw. But then one time in Detroit, one of the million shows I did last year, somebody brought a damn kangaroo on the stage, and that shit went viral. What happened was that this exotic animal handler who lives in Detroit said he wanted to come to the show. I'd seen him on Instagram. He's a guy who brings exotic animals to places like the projects where there are no zoos. For some kids in Detroit, this is all the zoo they have. And the guy had recently been all over Instagram walking a kangaroo around the city. He and his kangaroo were local celebrities at this point. I said sure.

I was psyched to have him and his kangaroo there backstage. That kangaroo was strong and healthy and seemed as happy and well cared for as could be. I got to feed it a banana and everything. I thought, *This is a*

real fun thing. The animal seemed so chill that when he said maybe at some point in the show, the kangaroo could run across the back of the stage and I could turn around like *What's going on?!* I said that sounded fun. We thought it could be a good laugh, especially because that kangaroo was famous in Detroit.

Well, I went out and did the show. The kangaroo never did come out, but that was fine, because the show was nonstop. Great show. At the end, I'd said good-bye to the crowd, good-bye to the host, and then I came out for one last good-night. They started playing a song by the Detroit rapper Tee Grizzley, which made the crowd go crazy, and I was dancing through the final good-bye.

Then, all of a sudden, the kangaroo guy is there on the stage with his kangaroo. From where I was, it seemed like the kangaroo and his keeper were dancing, too. After a few seconds, I got closer to them and the kangaroo took a swipe at me and I made a big show of running off the stage. And that was the end of that. I don't even think that animal had a minute of stage time. And I had no indication from where I stood that it was unhappy or scared at all, or that anyone was upset about it being there. After all, this was a professional zookeeper. The kangaroo was used to being in strange situations.

But later that night I went online and saw that video of me onstage with the kangaroo was everywhere, along

with coverage like I killed somebody. Online, I was getting death threats, getting accused of being an animal abuser, of torturing animals, of all sorts of fucked-up things. These people online were talking about wanting to put me in prison for cruelty to animals.

I felt horrible. I've been an animal lover my whole life. I've done a lot of work for them, too, including with Jennifer Pryor on her Pryor's Planet initiative to help animals. As an animal lover who's taken great care of pets and worked on their behalf for decades, I was so upset that anyone thought I would willingly make an animal upset. And I was mad at myself for letting the whole thing happen. I got why people were mad. When I watched that one-minute video, I could see the kangaroo looked freaked out, and it made me feel so bad. Real sorry. I came out and apologized to the kangaroo and to everyone else, and I donated money to groups that work for the prevention of cruelty to animals. Then I went on TMZ and apologized more.

That said, I also felt sick about how that one minute of a local zookeeper bringing a wild animal onstage is now the only thing a lot of people know about me. I hated that those seconds seemed to get so much attention, while the days and weeks I've spent trying to call attention to various causes, like inner-city poverty and

mass incarceration and even animal preservation, have hardly ever gotten one line of press.

I'm supposed to be funny and good at what I do. But when I do something really, really good, like a turkey drive back in my old hood with the Bembrys, getting food on everyone's tables, it's like a couple people look at it and say, "Aw, that was nice." But when I do something even a little bad, that shit is all over the press, all over the world. People commenting that I should get shot for it. Why do they seem so glad when I screw up? It's like they were upset I was succeeding, like it messed with their feelings about how things were supposed to go, and when I fall down at all, they're, like, *Thank God, now everything makes sense again.*

It sucks to feel like everyone's rooting against you, like you were set up to fail and then people are really convinced that you should fail. I had too good of a heart to be in the streets. I didn't belong there.

Now that I'm in show business, I feel that way all over again. It's Stephen Decatur High School. I'm in the special-education class. Everyone else is white, only sometimes I spot my friends from across the hallway. In Hollywood, the only guy like me is Mike Tyson. (Did you know he did time in the same Indiana prison I did?) It's as if you're always a suspect. No matter how good I

am, I feel like everyone's looking at me like the bad kid in school, just waiting for me to mess up.

Hollywood is tough—but it's even tougher to be black in Hollywood. This is not our business. I tell black actors and comics that all the time: Don't ever forget that. That's like watching a white guy get upset because he's not treated right in the NBA. I'm, like, *That ain't your game, man. You're good at it, and you're in it. But this is a black man's business, on the court.*

Slavery has a long legacy. And what it means in Hollywood is that black people compete with each other. They're always saying there's enough for everybody out there, but a lot of time you get black gatekeepers. Black gatekeepers are guys who are really, really rich, made a lot of stuff, but they control all the black people who want to work. You pick one black guy, give him everything, and say, "Go get your people and control 'em. You go act white with them. I'm white, you're black, you act like me with them."

I think a lot of stuff is just ordained in your life. I really truly think that us as black people, we are still feeling the effects of slavery. Stuff that wasn't even taught to us physically or in the presence of somebody, but it's just deep in us. It's a white man's world. Being black in America is dangerous.

No joke.

If you're black and you're on an elevator and a white woman starts screaming, you're going to jail, even if you didn't do anything, even if she just saw a mouse and that's why she's screaming. If you were in the vicinity and you look like me, it's a given: You will do at least three years. If, that is, you don't mysteriously die on the way there.

I know for a fact that white people don't understand what we go through. There's no way in hell that a white person can know. Ain't no way in *hell*. Every day before I left for school, I'd be told, "Let the Lord bless you or the mortuary gonna dress you."

I've never met a white person who heard that when they were heading out the door to go to school.

Still, for all the shit that we get as a race, if I could be reborn any color, I'd still want to be black. Maybe I feel that way because I don't know anything else. What I know is what it is to be black, so that's what I am and what I'll always be. And I've learned to own it, to own who I am and where I'm from. But being black sure has cost me a lot.

That's why I stick with the same guys who brought me. I've been with T.C. for twenty-five years; I've been with Niles for twenty years. People have been trying to get rid of Niles forever. Some people say it's the reason my career ain't where it should be, because I didn't have

representation from one of the big companies all along. But fuck that. I need people I can trust. I need people who can translate me to the Hollywood people and who can translate them to me. Niles speaks both languages.

Anyway, the awards shows, how they pick and choose who is the best, who Hollywood says is the best, is when I really see it stark. Leaning on that wall, looking around, I know I'm supposed to behave right. Don't drink too much. Don't say too much. But even when I behave right, it's still not like I get credit.

I have to take a step back and say to myself, "You know what? People think you don't need shit. People think you don't need nothing. Because your spirit is rich. Your look is rich. Your confidence is rich."

I can't be what Hollywood wants. I can't be what the Naptown streets wanted. But I can be what *I* want. And so maybe I have to start acting more like I feel, show who I really am. That's why I wrote this book. And that's why I'm glad I'm taking the kind of roles I'm taking now, like playing Richard Pryor.

17

BEING RICHARD PRYOR

The good news is that if you keep true to yourself and you can stay alive long enough, some amazing things can happen. Here's one: I'm going to be Richard Pryor in a biopic directed by Lee Daniels and produced by Oprah Winfrey. (She's also playing Richard's grandmother.)

When I was named the actor to play Richard Pryor, I think some people were surprised. And I know a lot of people were super fucking mad. That's because every black actor in Hollywood was waging a full-scale capture-the-flag campaign for that part.

I don't really have to audition anymore, but for the right role, I'll do it. And God knows this was the right role, so I auditioned for the Richard Pryor job. Hell, Lee Daniels made *Oprah* audition! I got to the building and came across Oprah in the waiting room reading the sides.

Oprah. Winfrey.

I thought I had the role the first time I read for the part, but they kept bringing me in again and again. And right when I'm sure I have it, I show up to what I think is the final round and I see Nick Cannon and Marlon Wayans going in the building.

But I knew it was the part I was always meant to play. I've been compared to Richard Pryor as long as I can remember. Maybe it's just because we both were skinny black men who liked cocaine and white women, but I like to think it's something more.

I met Richard years ago when his wife, Jennifer, reached out and said she wanted me to visit the house. Pulling into the driveway, I got chills. Something came over me: *You're at the master's house. You're here.* I prayed before I went in there. I came in and saw him in that wheelchair. I didn't know whether to cry or be happy. I'm grateful I was able to spend time with him before he died.

Once when we were sitting there, a maid walking through the room let out a huge fart.

"Her ass sounds like it's been tampered with," I said.

Richard, mostly paralyzed by that point, opened his mouth wide and let out a kind of braying noise.

Jennifer jumped up. "He laughed!" she shouted. "I haven't heard that sound in years!"

That was probably the most meaningful laugh I ever got. And there was something absurd about it: Here he is, arguably the best comedian of all time, and what brings him back from the edge of death to laugh again?

A fart joke.

I think I understand Richard Pryor so well because we both dealt with self-hatred and we both got saved by comedy. Comedy has saved my life again and again, and it still does, every day.

Also, we both had a hard time staying away from drugs. I've been struggling with cocaine since I was fourteen. It just was a habit that I had over the years that never really went away. I spent decades as what you might call a functioning drug addict. I've been able to keep it under control, but it's always discombobulated me. Wherever I was, I would get it. The whole time, from Indianapolis to Atlanta, New York to California. I think what drove me to doing drugs, especially when I moved to New York, was trying to forget who I'd been before. And I always thought cocaine opened up a third eye for me, a genius eye that I didn't have, that I couldn't tap into otherwise. Now, though, I can look back and see how much cocaine took from me, how it fed my self-loathing and kept me trapped. It's only now that I'm really getting out from under its power.

I tried to go to rehab once. In 2005, my wife, Mechelle,

told me I had to. She set it all up. I was supposed to check into this place in Santa Monica, get off coke for good, get right. I didn't want to go. But she said she needed it, and I didn't want to lose her.

In the car on the way to Santa Monica, I'm thinking, *I can do this. Maybe she's right. Maybe I need this.* I pull up in front of the place, turn off the motor. My suitcases are in the back. I'm about to get out of the car and check in. But first I sit in the driver's seat and look out the windshield. In front of the place there are guys and ladies standing around, smoking and talking. They're wearing jeans and sneakers. They look tired.

I sat there for a while watching them. It wasn't like they looked so fucked-up. I just didn't feel like I was there yet. "You out there, but you not out *there*," I said to myself.

I took a minute to see if I changed my mind. I didn't. I started the car back up, looked at myself in the rearview mirror, and said: "You know what you're doing."

And I rolled off.

Mechelle was mad as hell when I came home. Because I didn't go and because it was something she thought I needed help with. But I went off it myself and stayed off it for a while . . . until I binged. Then I went off it myself again for two years . . . until I had a bad week.

I always knew how to get it and how to hide it, but

now? I haven't been high in about two years now. Again I just stopped. I like to think I'm done, but I also know I have to be on my guard, because my pattern has always been that I'll binge for four days and then I won't do it for two years.

I don't know how it is I can put it down for that long, and I don't know why in the hell I relapse—the right atmosphere, the wrong people, something.

I never could get ahead of all the bad choices that I made. And when you can't get ahead of the bad choices you make, you continue to make bad choices, because you're in debt in your soul. Even though you try to understand the power of forgiveness, you still feel in debt.

Like, I think back about Yolanda and her parents, the Sharps, and I wish I could pay them back for all the shit that I did. I was so mean and so bad and just fucked-up, man. I hated myself then. So, if you're reading this, Boo and Karen: I'm so sorry that I was that way. I'll never forgive myself for treating you and your daughter like that. I hope the things I've done since then have showed you that I'm not all bad.

That's the thing no one tells you when you make it out of the streets, make something of yourself: You don't get a clean slate. You still feel like you're in the hole. Some shit you did, you can't come back from. You hurt people so badly. That's what happened to me. I think that I felt

so horrible and guilty about some of the decisions that I made, I was angry.

I'm haunted by who I used to be. The crime, the people I hurt, all that kind of shit. I've told you a lot of the worst stuff here, but of course I'm taking a boatload of shit to my grave with me. There ain't a soul on earth who doesn't. Nobody knows everything about you, nor you about anyone else. You don't know what the fuck somebody did or what they been through. You know what I mean? People say that's why I give away all my money, because I feel so guilty about how back in the day I was such a nasty motherfucker. Maybe that's true . . .

Thank God for my friends and my family who stuck with me.

You know, the first time I knew I might be funny was when I was a kid making my little brother laugh. Chaney was my first friend and my first real fan. I have a lot of brothers and sisters, but he was the one person who I wanted to impress, who always had my back. He made me think I was special and gave me confidence. I've been getting that support from him since I was a kid. It's hard to make your brother laugh just sitting around the house: This is someone who knows all your tricks, all your bullshit. But I'd get him to laugh, and when he did, it was like the sun coming out.

I think back on kids Chaney and I grew up with who

never got out, never figured out what they had to give the world. Even if they did find their talent, a lot of them couldn't figure out how to sell themselves to the world, to get out from under the curse of being born black and poor. And it's hard to have a great product with no advertisement. Some of the most famous people in the world aren't even talented—they're just great promoters. I thank God every day that I was able to find out what I was good at and to figure out how to sell it to other people enough to make a life for myself.

Every day I think about how it could have gone instead.

I had a friend back in the day, Calvin Richardson—we called him Cal-Cal. He was actually funnier than me, *shiiit*. He could stand on a corner for hours telling stories, and everyone would be doubled over, laughing so hard. My whole neighborhood used to brag on him. People would say to me, "Motherfucker, you ain't the real deal. *Cal-Cal's* the real motherfucker."

But he stayed in the hood.

Once I got famous, I went back to Indianapolis to do a show at a giant fucking theater. It seats, like, two thousand people. And I thought, *I'm going to give my old friend his big break,* so I put Cal-Cal's ass on my show.

Cal-Cal got up there and started telling his jokes. I'm sorry to say that from the start I didn't think it was going

right. Hood funny is different from being in entertainment. "Yo mama" jokes may kill with your brothers, but unless it has more to it, that shit doesn't always work onstage. You have to win people over, lead them to the punch line. It takes a lot of practice and experience. I've had thousands of hours of stage time and I'm still learning all the time. I bet Cal-Cal could have been great with more experience, but that night he bombed.

One of the worst things about finding what my talent is has been the remorse about all the people I knew coming up who didn't make it out and didn't live up to their potential. It's so lonely to be the only one. You end up sabotaging yourself sometimes, because you're all alone. You're not joined by a crew that believes what you believe and has seen the things you've seen. So many of those people are dead, or stuck.

It's just you.

When I got to New York, I'd had a presence about me but I needed so much work to get really good. I walked away from the person I used to be a long time ago. Sometimes I imagine that guy I was, sitting there on the porch, waiting on me to come back. Well, I'm not coming back. I left your ass in Indiana for a reason. I had better places to be.

Today, I realize that I only made it in show business because I didn't know I was going to make it. It's counter-

intuitive but it's true: If I knew I was going to make it, I wouldn't have made it. They say the old-time stars were born, not made, and I think that's still true. You have it in you from the start, but you still have to cultivate it. You have to become more and more yourself.

I hate the things I did before I found comedy. What a waste . . . but I also use it as a badge of honor. Because not a lot of people I know now have seen what I've seen and done what I've done. A person would have to go live it to understand it. And most of the people who lived it are dead. All that street stuff helped make me who I am, because I had to get away from it. I was out there searching, trying to find out who I was. When I found comedy, my life turned around.

This is true for everyone: Your talent can save your life—if you can find it. That's the key. Everybody has a talent, but the key is you've got to be able to find it. I've seen so many people fail because they couldn't find their talent. Some people go through a whole lifetime without ever finding their purpose. Other people find their purpose and then they don't use it. Maybe they're too arrogant; maybe they're too scared. But for whatever reason, they know what they have inside them and they don't let it out, and I think that's almost worse than never finding it.

I do still get the fear, though. Your talent can make

you shy. It can make you very vulnerable to know you have this thing that you care about, that's the very core of your being, and to know you have a destiny to show it. It's hard to live with. That's the thing about being a talent and an entertainer: It can be a burden as much as a gift. It's hard to live with the fact that people depend on you to make them happy; even if you were blessed with that talent and know you could make them laugh, you don't always want responsibility for that shit. People say, "You're a comedian. Say something funny." I hate that. I want to tell them, "*You* say something funny, motherfucker."

"Tears of a clown" is real. Your job is to make people laugh, so people expect to see you happy. I get that from people: "You're a comic. You have money now. You don't have a right to be down, to be sad. You don't have a right to be anything but happy." They don't care that I'm a person who's suffered and suffers still.

I been acting out a long time. When I was bad, I was bad, but you know, I spaced it out. I didn't do a whole bunch of petty bullshit things. I'd be good and good and good and then I'd do something dangerous.

The good news is that one sin isn't bigger than the other. Forgiveness is a powerful thing. To be able to live with yourself through forgiveness is a strength in its own right. It's something that you have to go to work out

just like a muscle at the gym, and you have to learn how to forgive. Some people ace it; some people don't know how to do it, period. Some people know how to train to learn how to do it; some people take their time and learn how to do it, however they deal with it. That's my way, actually: I try to remember that it's only so many minutes in a day, so many hours in a day, and I need to make it through the day, listen to the good voices in my head and not the evil ones.

I know I've had a death wish. Whether it was street shit, getting high on drugs, having sex unprotected—I can see that what I wanted was to accidentally die. That's some fucked-up shit.

Maybe I wanted to die, too, because I'm not afraid of death. I believe in the afterlife. I believe heaven is the spirit. I think the spirit lives in things and lives in people. You ever meet a person for the first time that you thought you already knew? People love people and don't know why they love them, have no idea what it is about this person that they like, but I really think that could be something from a past life, you know what I mean? It's nothing to be weird about. It's good. It's beautiful. It gives you hope. It'll make you say, "Damn. I shouldn't be in fear of the next life."

In another life, your spirit could have been somebody from anywhere, somebody that you never knew,

or perhaps one of your ancestors or somebody that was related to you. Any race, any religion. You never know who you were in the past or who you'll be in your next life.

The skin really is just the shell for the real, and it's like once you understand that, that it's just a shell, you can see that people who really love you love you because of your spirit. I think that a charismatic and entertaining spirit lives in me and that all the trials I've been through have just made me better able to express that spirit.

This is what Richard Pryor knew: Comedy comes from pain, and the more pain you've fought through, the funnier you can be. The only way you get that is to be *in it*. And not look at it from the outside. I decided I had to learn to love pain because it made me funny. The more I went without, the funnier I would be. To this day, I think I still hold myself back sometimes or that I'm too hard on myself, because I want the raw and the gritty.

To be truly funny, you have to sacrifice everything: relationships, your mental health, often your physical health, too. It's a very self-destructive sport. And a lot of people take from people with talent. And they don't just take money—they drain *you*. People who make a living from your talent, they're not always considerate

of you being a normal person. It's like you're Superman, but you're not. You go through what everybody else goes through—and you're expected to smile. You find yourself plastering a smile on your face, trying to please people, and you're struggling on the inside.

One thing about having talent is once you discover you have it and you share it with the world, you can be very lonely. I've been in a room with ten thousand people and felt totally alone. I can see that they're laughing, but what am I getting out of it? There's the money, of course, and there's the instant gratification of seeing them laugh . . .

. . . but I think I've come to understand that the real thing is that performing lets me lose myself. When I'm onstage hearing people laughing, in that moment of performing, nothing can faze me. If I'm onstage while the world is ending, I won't see fires, I won't see buildings fall. I'm in my craft. Offstage, I'll be just as scared as all you motherfuckers. But while I'm there in the spotlight, nothing else exists. Comedy has given me almost everything good in my life, but the best thing is probably that: the moment when I can forget it all.

For that moment onstage, it all melts away.

EPILOGUE: HOLLYWOOD TO NAPTOWN

Not long ago, I was invited to perform at Folsom Prison, the California state prison where Johnny Cash famously sang for the inmates.

For me it was a truly humbling day. That day, I met a twenty-three-year-old kid who reminded me a little bit of me.

"How long you been here?" I said.

"Since I was nineteen," he said.

"Well," I said, "do your time and learn your lesson, and when you get out, you can make something of yourself. How much time do you have?"

"Two hundred years," he said.

"Two hundred years?" I said. "Wow. That means your parole officer hasn't even been born yet. He's still swimming around in some white man's nuts."

My childhood was so fucking crazy for so long; I'm much calmer now. I'm still just trying to survive, you know. What I've realized is that the two ends of the

shoestring lacing my life together are pain and comedy. Every minute of every day, those are the two things I'm dealing with, and every part of my life, they've both been with me. And every minute, I've felt like I was living in some kind of movie, some kind of dream.

These days, it's like every day is a dream I don't want to wake up from. I'm spoiled. I stay at nice hotels and eat good food and wear new clothes. In this new world I'm in, people carry your bags, floors are made of polished marble, ceilings are high, trees grow indoors, the lighting is soft and flattering. There is faint, soothing jazz and the sheets are soft. There's a buffer between you and the world. If you're looking for the opposite of where I grew up, here it is. I like it. It still doesn't feel real, though.

It's taken me so long to appreciate nice things, and now I finally do, and really, if I'm not around it, I'm a brat. I heard myself complaining about a hotel the other day and I was, like, *Oh shit, I finally got used to it.* I've had so much remorse about making it and being famous because I know what I've been through and what I did, and all the people who didn't make it.

If this is the dream that I'm dreaming, my past feels like a nightmare. It feels like someone else. I really didn't ever want to be that guy. I didn't really want to be a criminal. But crime was the only route I could see. Me

doing crime was economics, pure and simple. That wasn't me being a criminal; that was me trying not to die. Once, I didn't want to do nothing but pay my bills and have food in the house and have a car and a girl-friend and live happy.

The toughness was just something I used to get by. My imagination led me to the streets. Crime was just a mor-sel of who I was, and now show business is just a morsel of who I am. My life is not about the fact that I made it in show business; my life is about survival. But I've always felt sort of on the outside. I felt like I didn't quite fit in back on the streets and now I feel like I don't totally fit in fame, either.

Back in Naptown I was too nice, too sensitive. In Hollywood, I'm too rough around the edges. But every day I'm grateful for what I have. A lot of my friends who survived have had to fight so hard to get good lives. My guy Jeff is still alive—he's been shot eighteen times (but he says fourteen of those were all at once)—and he somehow survived. We sit around now and feel so lucky to be alive.

My guy T.C. is kind of my soul brother. I think God sent him to me. This little Mike Tyson–looking mother-fucker, he's still my friend to this day. Ever since I met him in New York twenty years ago, he's kind of been like a voice of reason. But he's never wanted attention.

I barely even talk about him, because he's that type of guy. He's, like, "You don't have to tell nobody about me. My work speaks for itself."

And my mom. I honestly think my mom has kept me alive just because of who she is and how she raised me. The thing of it is that when I see all these guys that I was around that died, I'm, like, *Man, I'm a lucky dude.* I think the way my mom raised me really protected me. I was so scared the whole time I was in the streets.

These days I'm trying to do the right thing. And I'm trying to understand why I've done what I've done in my life. I think often about how I was raised knowing God but I've ventured off from the true path plenty of times over the years, but I still believe in God and believe that this life is just the appetizer of your real life, you know what I mean?

Over and over, I've tried to turn my life over to God. But it's always been more like *Hold on one second, God. I'll get to you, I promise. Let me just make some money first.* You feel me?

I'm so grateful my mom is still around. But I know even after she dies, my mom will be with me. I tell people all the time, people that have lost their parents, "You only lost the shell of them. You didn't lose them, because they *are* you, and you are them."

You are your fucking mother and your father. Through-

out the day, I can feel my mother in me. Sometimes I'll be doing something and I'll think, *Wow, that was some my mama shit I just did right there.*

My brother John likes to say that we kids are half-sweet and half-tough. He says we all got the sweet and funny and nice because of our mom, and we're all rough because of our dads. He says it explains how all through our childhood we could go from being your friend to whipping your ass.

The law of the streets is to never forgive and never forget. But as an adult I've forgiven people who did me wrong or who I used to be angry at. Even though I was so mad at Reggie when I was young, I understood him when I got older. I mean, he had it rough, too. He took a chance and married a woman who had five kids, and it must have hit him later like *What the fuck am I doing?* But it was too late for him to change us, and there we were, going bad, getting in gangs. He wanted to save himself and save one of his kids. I understand him better now that I'm an adult. None of us hold a grudge. I've talked about it with my brothers. We were so fucked-up about it at the time, but I think in the long run having to fend for ourselves from a young age made us better men.

Now that I'm famous, I can reach back in my past and see it in a positive way. I can look back and remember a moment, even a terrible moment, and see it as something

that got me here. My past could have made me weak, but it made me the opposite. My present is my past. Now that I'm in this world, in Hollywood, I meet people with similar problems to what I had, or with less problems than I had, or with more problems than I had. And I can see my problems for what they are: mine. That's what I'm responsible for, and I hold on to that.

My mom has suffered so much in her life. And yet, she is where I get my sense of humor, too. She is so great at being sarcastic. She asks me for some money sometimes, and here's how she asks: "I bet you won't give me $500."

"How am I going to win that bet?" I say, laughing. "I have to give it to you."

That is one thing I'm grateful for: being able to help people, give them a roof over their heads, bail them out when they get stuck.

I own twelve buildings in Indianapolis. One of them is the oldest house in the neighborhood. It was built in 1869 and I almost completely restored it. I support more than twenty-five people a month, mostly family members. And I have my own charity foundation. I go around the country and talk to at-risk kids. I meet so many kids that are like me, that are lost and are just trying to find their way. And I tell kids all the time: If you find your talent, it'll save your life. 'Cause that's what it did for me.

So that's my life now. I help people. Me. The kid in the Toughskins and Garanimals that never had enough food in the fridge. That got Fs and suspensions. Ain't that crazy?

Here's some more irony for you: My old part of Indianapolis was so bad, so rough. But now? Now Mapleton is a goddamn designated historic district. That's right, that shitty neighborhood is now a place people actually want to be. Gentrified as hell. And that means the property I own has more than sentimental value. It's actually worth something now. An investment.

If I hadn't helped all the people that I helped, I would never have to work another day in my life. I give away a lot of my money. I've given away so many millions of dollars helping people, giving people stuff, doing stuff for people. And I think I got that from my mom. My mom would give you the shirt off her back. She's a giving person. I love helping. I love giving people stuff, watching people smile, you know?

I love seeing people's faces light up when you give them something. I think about when I was a kid. I think if someone gave me something, some money or some candy or fucking anything for nothing, how good it would have felt.

Man, I tell you, if I didn't help other people, I could have retired years ago. But I feel like it helps me get over

guilt I have for how bad I was back in the day. And it makes me feel a little less bad about surviving when so many of my friends died. A part of me doing good things for people and stuff is I wish I could pay for everything I feel bad about.

And when someone calls me up from the old days, what am I gonna say? No?

I got a call that my friend Fatso died. My guy Fatso and I used to be so tight. And what do I hear on the phone from his mom? They can't afford to bury him. He's going in a pauper's grave.

"The state's gonna put him in a plastic container, Mike," she said. She was crying. "You know that's what they do with people who don't have insurance or nothing."

"Nah," I said. "Stop crying, now. We gonna give him a good burial. Fatso's not going out like that in no plastic box."

I sent her money to bury him right.

I've paid for so many funerals. I can't even count how many. Once I got to show business I always got calls that all my friends died and they'd ask if I could help with costs. Once I left Indianapolis, every time I looked up, somebody was calling me, telling me my friends were getting killed and no one could afford a casket.

I hate going to funerals, though. It's just too much.

When I go home, I want it to be to see my mom, not to spend a whole day at Crown Hill Cemetery thinking about how there are almost none of us left from the old days.

Some of the deaths hit even harder than others.

The worst, I think, were Gary and Otis, from the barbershop, who dared me to go to the comedy competition and started me off in entertainment.

Gary Bates had been a street dude back in the old days and I heard he'd gone back to being a stickup guy. Might have stuck up the wrong person. Someone shot Gary in the head twice and burnt him up in the trunk of a car . . .

Otis Brown had ended up being like a Martin Luther King Jr. in the neighborhood. His shop was in a bad part of town, Thirtieth and Clifton. He was always collecting toys for kids in need and he'd employ anyone who needed a job. You'd go and there'd be ten guys in that shop sweeping hair. Tough, street guys, too, just out of prison. It felt like the county jail in there. He was hiring all these guys from prison to cut hair, because they couldn't find other jobs. But it felt like prison in that shop. The atmosphere was *hard*.

After hours, some of those guys Otis had hired would play crap games and gamble down in the basement. Well, one night some young guys were down there

gambling. Otis went down there and one of the kids snatched his money. Otis grabbed the guy's arm, and the guy pulled out a gun and shot Otis in the chest.

I was in Hollywood when I heard. *Oh, God, not Otis, too,* I thought. Otis, who only wanted to help people. Otis, who worked two jobs until he could afford his own shop. Otis, who always gave back. Without Otis and Gary, I probably wouldn't be where I am today. I think of them every time I'm back in Naptown. I wish I could go to the barbershop and sit and talk with them again.

And I wish they could see where I am now.

Going home isn't easy. Sometimes it feels like I never left. You feel me? It's crazy, because by me living in Hollywood and being an entertainer, no matter what I've accomplished and what I've gained financially or anything monetary, when I come back home it feels like I never left. I start to fall back into it, what it felt like to be there. It takes about two days and then someone says, "You better get your ass out of here."

Why is it that sometimes I can feel like a big deal in Hollywood but still like a broke kid in Naptown? Your hometown don't *treat* you like it's your hometown. You can't even sell these sons of bitches a T-shirt. I always knew from the Bible that no man is honored in his own hometown. Watching *The Ten Commandments*, I said to myself, *Damn, Jesus sure wasn't the man at home.* At

home, that's who tortured him. People he knew, who he grew up with.

In 2010, the Indiana Black Expo gave me its Entertainer of the Year Award, and I was given the key to the city, presented by the mayor himself. Back when I was a kid, I was on the news as an example of what was wrong with the city. Me, who used to rob and cheat and steal. Me, who used to be hungry and depressed. Me, who played Russian roulette. Me, whose friends died or went to jail one after the other.

Now I got to go back in glory.

There I was, standing on the stage, all dressed up, getting a standing ovation from a convention hall full of people. Mayor Greg Ballard said of me, "There are many people who leave this city and never look back, but there are a few extraordinary individuals who never forget their roots."

In my acceptance speech, I thanked God and my family for giving me another shot at life. I thanked my father for paying my lawyers to keep me from going to prison for a million years. That got a big laugh.

"I was once one of these young kids out here," I said. "I finally got it together." I told the crowd if anyone wanted to use me to help motivate their kids, to show that it was possible to do something with their lives, then I was happy to serve.

Then, at the lunch reception, I saw this guy who had been a corrections officer at the Marion County Jail, where I'd served time. I was standing there, talking to a bunch of politicians, and he came over. He was a mean son of a bitch, but now here we were both reputable members of society, so I said hello. I could look past him being an asshole to me when I was inside. He could see how I made something of myself. It felt good. There we were, both in suits, both doing right for the kids.

I greeted him with a smile.

"Hey, Mike," he whispered to me as he shook my hand. "It's in the hole."

That mother*fucker.* He took me right back to that time in jail when they serve the food through a slot in the steel door: "It's in the hole!"

This motherfucker, trying to put me in my place. At a time like this. God forbid I go one day without being reminded where I came from. *That mean motherfucker,* I thought. *He can kiss my ass.*

I wanted to punch him out. I wanted to tell him to go fuck himself. But I didn't. You know, we were there for the kids, and I didn't let it bother me, because no one else in that room knew what that meant. I saw the mayor and those other politicians standing by us thinking, *In the hole? What's in the hole? What hole?*

And I looked at him and I thought, *You're the one in the hole, you bitter son of a bitch.*

I just smiled at him. And I said good-bye. And I took my key to the city back to my other life, the one that still feels like a beautiful dream.

ABOUT THE AUTHOR

Mike Epps has appeared in the cult hits *Next Friday*, *Friday After Next*, and *All About the Benjamins*. Other features include *The Hangover* franchise, *Faster*, *Hancock*, *Lottery Ticket*, *Next Day Air*, *Roll Bounce*, *The Fighting Temptations*, the *Resident Evil* franchise, *Bait*, *How High*, *Dr. Dolittle 2*, *Talk to Me*, and *Guess Who*. He has also starred as the title character in the ABC series *Uncle Buck* and appeared on the Starz series *Survivor's Remorse*. As a touring comedian, he's played clubs, theaters, and arenas worldwide. Born and raised in Indianapolis, he now lives in Hollywood.